THE
STROUDWATER
AND
THAMES & SEVERN
CANALS

From Old Photographs
volume two

EDWIN CUSS & MIKE MILLS

AMBERLEY

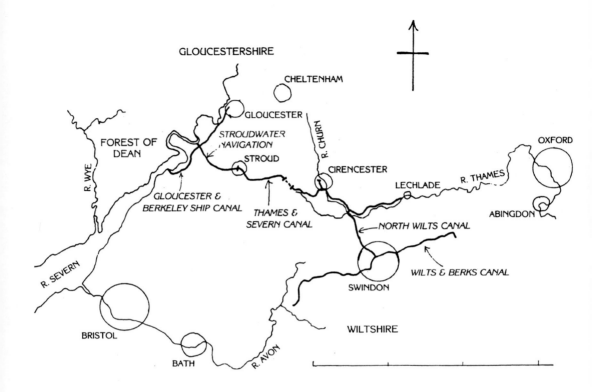

First published by Alan Sutton Publishing Limited, 1993
This edition published 2010

Copyright © Edwin Cuss & Mike Mills, 2010

Amberley Publishing
Cirencester Road, Chalford,
Stroud, Gloucestershire, GL6 8PE

British Library Cataloguing in Publication Data.
A catalogue record for this book is available from the British Library.

ISBN 978 1 84868 787 5

Typesetting and origination by Amberley Publishing
Printed in Great Britain

Contents

Foreword

Since the publication of the original book in 1993, Stanley Gardiner passed away in 1997.

Starting in the late 1960s and onwards until his death, Stanley Gardiner and his friends Lionel Padin and Mike Mills, who were all born and bred Chalfordians, became aware that the village was changing dramatically and they endeavoured to gather together information and photographs about Chalford before it was too late. Inevitably, this search expanded into the whole surrounding area. A huge amount of material was collected, collated and photographed and this collection led to the publication of many books on local subjects and Stanley Gardiner's untimely death was a great loss in this respect.

Edwin Cuss and Stanley Gardiner collaborated on the publication of the original book in 1993 but in order to reprint this book it was necessary to move with the times and the rapidly changing technology of publishing, therefore Edwin Cuss and Mike Mills, with the blessing of Mrs Nancy Gardiner, have been able to search out most of the original photographs for digital screening, compared to the photographic process used in 1993. The captions to the pictures and the Introduction have also been altered where necessary to cope with the passage of seventeen years. We were unable to trace a very small number of the pictures and a few have been changed, but basically this book remains a reprint of the original.

March 2010

Introduction

This second volume of photographs showing the Stroudwater and Thames & Severn Canals is a sequel and supplement to the first volume and perhaps both will be best enjoyed by reading the books together.

Photographs are fairly abundant from the River Severn up the two canals to Sapperton, but less so on towards Cirencester and South Cerney, and fairly sparse from there down to the River Thames at Inglesham. From the River Severn through the Stroud Valley and the Golden Valley, industry, which could use canal traffic, and large populations were commonplace. Once over the summit level the only large centres were Cirencester, Cricklade and Fairford and even then the Thames & Severn Canal's main line bypassed these centres, so that for miles on its journey to the River Thames it passed tranquilly through farmland. One can well understand why commercial photographs along these lonely stretches are sparse. Even so the canals today, derelict as long lengths are, still present a fascination to many people, if only for a quiet ramble away from the mayhem of modern times.

For the first thirty-eight years of their joint existence, the Stroudwater and Thames & Severn Canals formed the link between England's two longest rivers, but with the opening of the Gloucester and Berkeley Ship Canal this gave the opportunity for traffic on the two canals to avoid the vagaries of the River Severn below Gloucester and, of course, meant a decrease in traffic between Framilode and Saul Junction unless it was to or from the Forest of Dean ports. Therefore the first few pages of this volume are devoted to a few scenes at Gloucester Docks and on the Gloucester and Berkeley Canal. Thereafter, the Stroudwater and Thames & Severn Canals take over, until the River Thames is reached. The book closes with a few scenes of the upper Thames.

When the restoration of the two canals along the whole thirty-seven miles is discussed, the spectres of lack of water on the summit level, and losses elsewhere due to the underlying strata, are always raised. However, modern technology already has the means of eliminating these losses. Few seem to realize that difficulties were experienced

by nineteenth-century bargees too. Letters to James Smart of Chalford from his bargemasters repeatedly mention lack of water, weed blockages and other problems in the upper Thames below Inglesham, arising from lack of maintenance by the Thames Conservancy. It follows that with the present-day falling water tables in the upper Thames area, the lack of water and leakage problems in restoration are possibly not solely the province of the Cotswold Canals Trust.

Much has now been lost due to lack of foresight in the past, and large scale restoration is required. This restoration is in the process of being initiated with Phase 1 underway from The Ocean at Stonehouse through to Brimscombe Port. This inevitably means that the trust has to alter its aims from time to time, so that restoration work can run as smoothly as possible within the resources available.

With present-day technology, the mechanics of restoration present no problem, but financial, professional and voluntary work does. It is to be hoped that the current interest in linking waterways, not only for leisure activity, but also to provide a simple means of connecting areas of higher rainfall in the west and north to drier areas in the east and south, will not decrease as we move forward into the twenty-first century.

For those wishing to gain a deeper insight into the canals there are five excellent books on the subjects.

The Stroudwater Canal by Michael Handford, Alan Sutton Publishing 1979.

The Stroudwater Navigation by Joan Tucker, Tempus Publishing 2003.

The Stroudwater and Thames & Severn Canals Towpath Guide by Michael Handford and David Viner, Alan Sutton Publishing 1984 and 1988.

The Thames & Severn Canal by Humphrey Household, Alan Sutton Publishing 1969, 1983 and new edition Amberley Publishing 2009.

The Thames & Severn Canal History and Guide by David Viner, Tempus Publishing 2002.

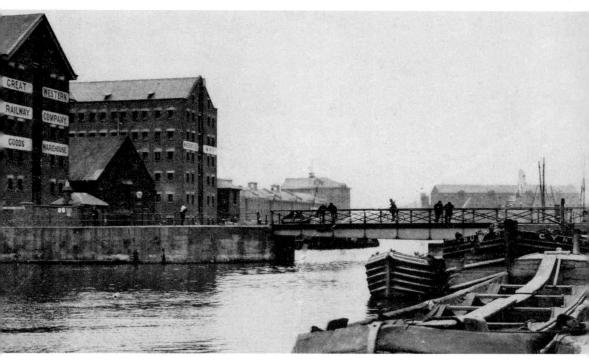

GLOUCESTER DOCKS, LLANTHONY BRIDGE, *c.* 1905. This is the view from Llanthony Quay into the main basin through Llanthony Bridge. The warehouses, left to right, are: Great Western Railway Company Goods Warehouse, Fox's Malthouse (the low building), Alexandra Warehouse, West Quay Warehouse, Lock Warehouse (now the Antiques Centre), North Warehouse (in the background).

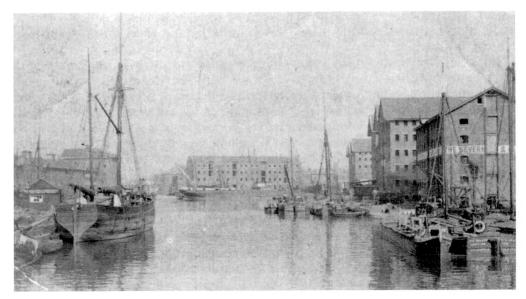

GLOUCESTER DOCKS, *c.* 1910. A busy Edwardian scene in the main basin, looking north to the long North Warehouse. The Severn & Canal Trading Co. occupied Biddles and Shiptons Warehouses, and on the right a trow and a longboat are moored by Biddles Warehouse. To the left of the ketch is the small office of the Gloucester & Sharpness Canal.

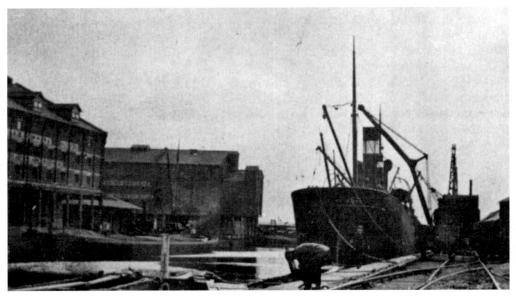

LLANTHONY QUAY IN GLOUCESTER DOCKS, 10 April 1912, showing the GWR goods siding (although both GWR and MR wagons are present). From the funnel markings of the steamer it appears to be a vessel of the Bristol Steam Navigation Co., and must have been quite large for the canal. It was possibly lightened at Sharpness by offloading some of its cargo.

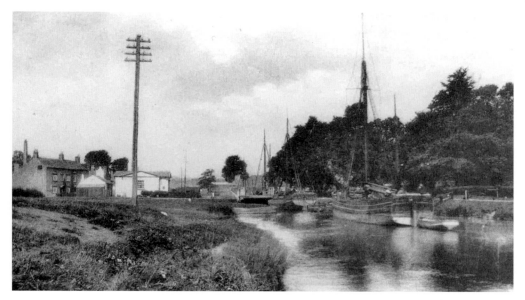

PURTON, *c.* 1910. Trows pass through the Upper Bridge going towards the Severn, where the canal turns south to run parallel to the river to Sharpness. The grassed area is now a public car park, while the building adjacent to the bridge cottage is now an extension to the cottage. Westville Terrace (three dwellings on the opposite side of the road) is still there, but the tall chimney has gone.

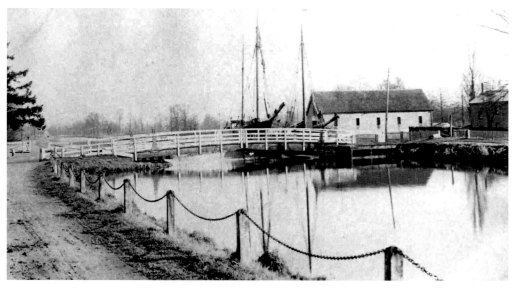

UPPER BRIDGE AT FRAMPTON ON SEVERN, *c.* 1900. Upper Bridge takes the road from Frampton to Arlingham, Saul etc. The five-windowed building is now the premises of Indent and Artificial Images, but it may once have been a small warehouse for the wharf there, where the trow and ketch are moored. In the empty area beyond the boats, the Cadbury Milk Depot was soon to be built.

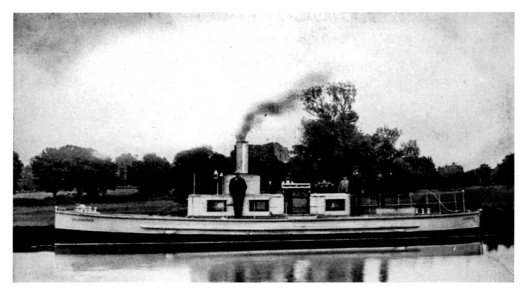

SALAMANDER, 12 July 1906. The *Salamander* was built by Abdela & Mitchell Ltd at their Hope Mills works at Brimscombe for use as the City of Gloucester Fire Float. She is seen here moored up but ready for action if required on the Gloucester and Sharpness Ship Canal.

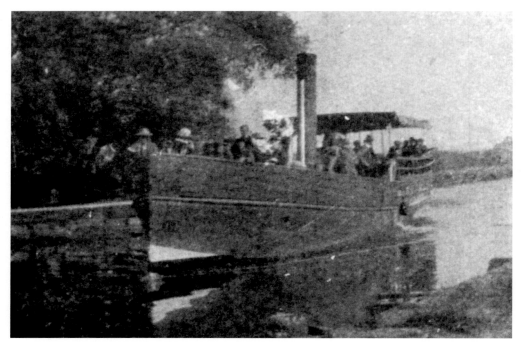

THE STEAM PACKET *WAVE* (*c.* 1910), somewhere on the Berkeley Canal with a good complement of passengers. With her sister packet, *Lapwing*, she plied daily between Gloucester and Sharpness, carrying goods from the canal hinterland to market and people to Gloucester shops.

Stroudwater Navigation

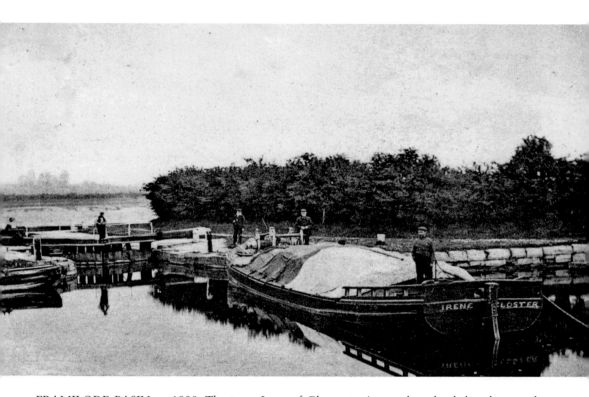

FRAMILODE BASIN, *c.* 1900. The trow *Irene* of Gloucester is seen here loaded and moored in Framilode Basin complete with crew waiting for the right tidal conditions in the River Severn before she leaves the lock out onto the river. Framilode Lock was the first lock into the Stroudwater Navigation and at this time it was mainly boats from the Forest of Dean across the river that would be the traffic in and out of this lock. Most other boats would access the Stroudwater Navigation by using the Gloucester and Berkeley canal.

There is a message on the back of this postcard to Mrs Lewis of Gloucester from HA and GB:-

By the boat tomorrow night
Home will come two stars of light
Though the rain is very wet
It has not drowned us quite, as yet.

FRAMILODE SWING BRIDGE, *c.* 1905. Looking across the bridge towards St Peter's church. The terrace of nine houses has been demolished and replaced by six modern dwellings, while the canal has been infilled. To the right of this bridge the canal widened out to the basin and small wharf, before passing into the outfall lock to the River Severn.

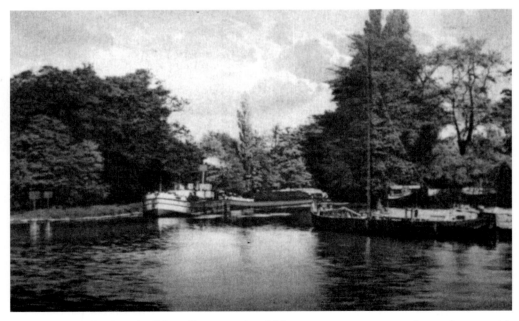

AT SAUL JUNCTION. An Edwardian scene in which a steam tug appears to be stationary, with a large loaded barge in tow. There is a moored trow on the right. The picture is believed to be near to the Junction.

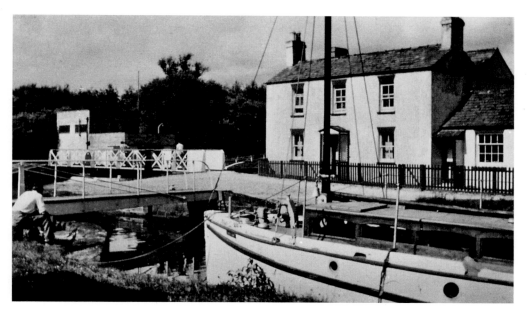

JUNCTION HOUSE, 1953, from across the Stroudwater Canal. The little swing bridge to the left connects with the dry dock and boatyard. Note the stopgate grooves, visible below the bridge. The main swing bridge for the Sharpness Canal shows immediately over this little bridge. Before the Sharpness Canal was cut, the Stroudwater Canal passed behind the house.

JUNCTION BOATYARD, c. 1910. A trow is being launched sideways into the canal. The yard is still active today.

ABOVE THE JUNCTION, *c.* 1930: probably a view of the mooring facilities on the Stroudwater Canal. The view is looking westwards, possibly from Stonepits or Occupation Bridge.

APPROACHING WALK BRIDGE at Whitminster, *c.* 1925.

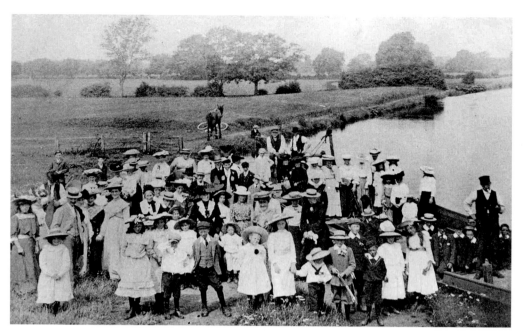

WHITMINSTER WHARF, *c.* 1910.

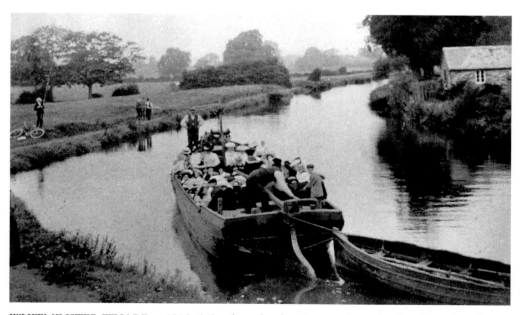

WHITMINSTER WHARF, *c.* 1910. A Sunday school outing or a large family trip, gathered (top) on the bank opposite the wharf. The photograph was taken prior to embarkation on a barge for a trip west, perhaps to the Junction. The poor old towing horse (or mule) looks as if a square meal would not be amiss. Note the health and safety requirement in tow in the lower view as the trip gets under way!

AT WHEATENHURST UNION WORKHOUSE, *c.* 1900. This is on the canal between Westfield Lock and Court Orchard Lock. These two locks are the first and second of five locks built on the canal from the Bristol Road level up to the long Stonehouse pound.

NEWTOWN (*c.* 1915), looking west down the canal, probably from Roving Bridge. The houses on the right are at Newtown.

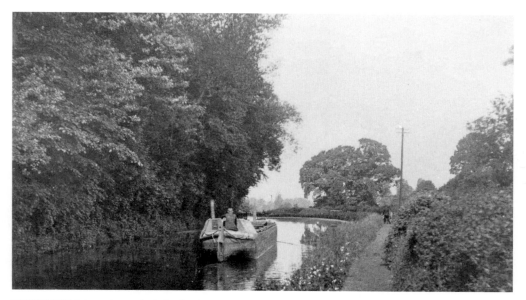

NEWTOWN (c. 1915) slightly further west, possibly between Nassfield and Blunder Locks. A donkey or mule seems to be towing. Note the stovepipe for the barge cabin.

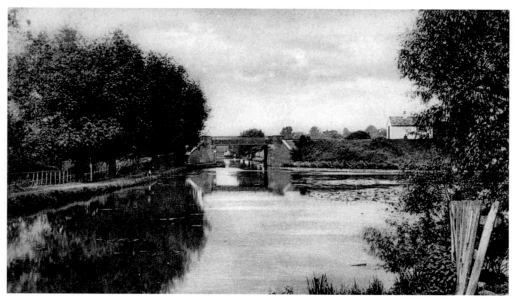

THE 'OCEAN' AT STONEHOUSE, c. 1910. West across the canal is the bridge carrying the Midland Railway from Gloucester to Bristol. Part of Bonds Mill can be seen in the distance, framed by the bridge. To the right, the Ocean had a small boat repair yard close to the railway. A small wharf there could have served to supply material for the railway, but there is no proven evidence that it was used to tranship goods between railway and canal.

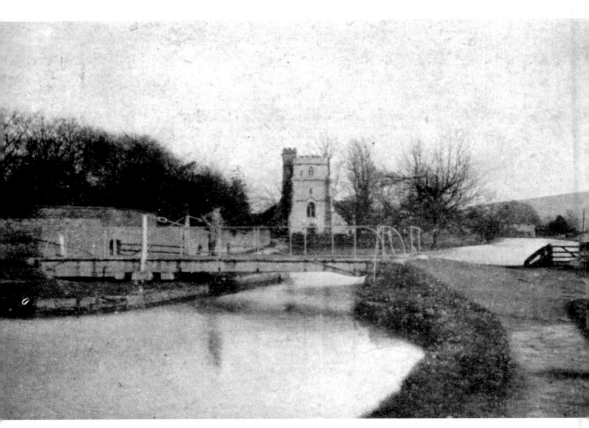

STONEHOUSE CHURCH AND SWING BRIDGE, *c.* 1900. The swing bridge crossed the canal at the east end of the Ocean, and this shows the complete bridge, which had iron girders with a wooden planked deck. The deck was tensioned by adjustable steel rods. The bridge gave Stonehouse Court Farm access to farmland that had been cut off between the canal and the River Frome.

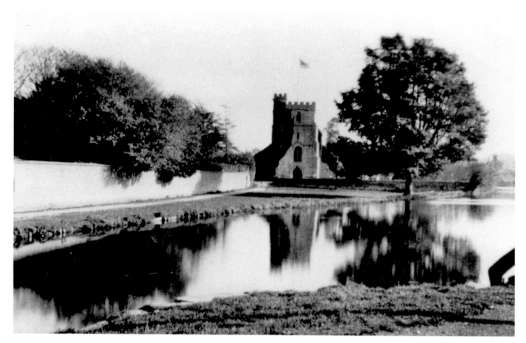

ST CYR'S CHURCH, Stonehouse, *c.* 1915.

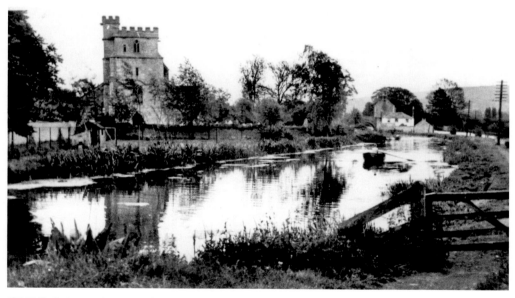

ST CYR'S CHURCH, Stonehouse, *c.* 1930. After leaving the Ocean the canal regained its normal width, passing beneath a swing bridge into the pound at Stonehouse church. The top view shows the canal weed free, while the lower view shows Nutshell Bridge and House in the distance. The high wall of Stonehouse Court, with its back gate, is on the left.

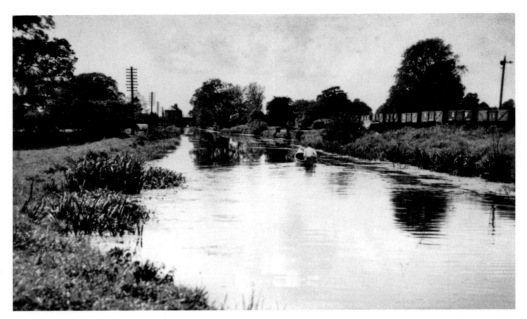

THE POUND BELOW STONEHOUSE, from Bridgend Bridge, *c.* 1930. Here the canal is adjacent to the LMS Railway branch to Nailsworth/Stroud, evidenced by the variety of different company goods wagons. The lone canoeist is probably a Wycliffe College student.

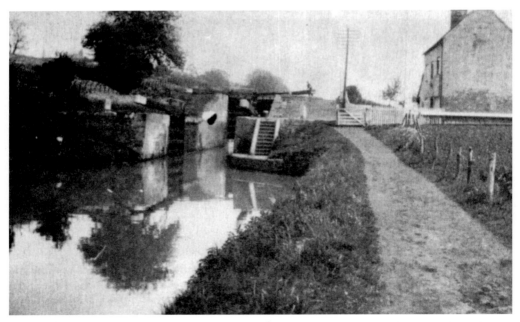

RYEFORD DOUBLE LOCK, 1911. The view from the west, with the lockhouse on the right.

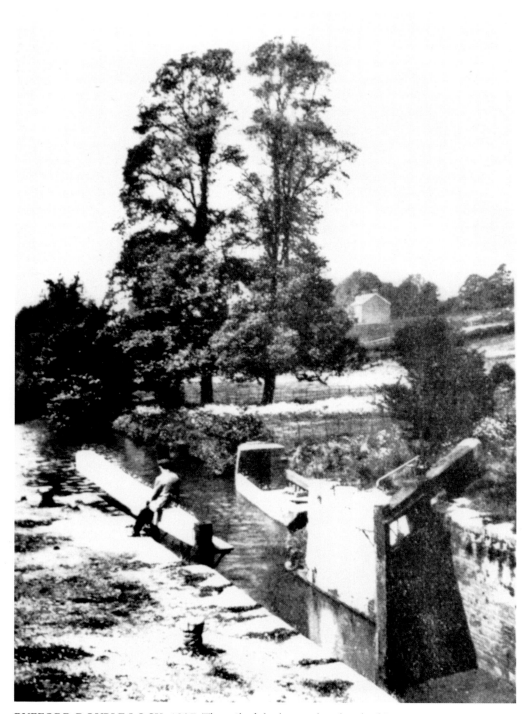

RYEFORD DOUBLE LOCK, 1927. The tail of the lower chamber, looking west.

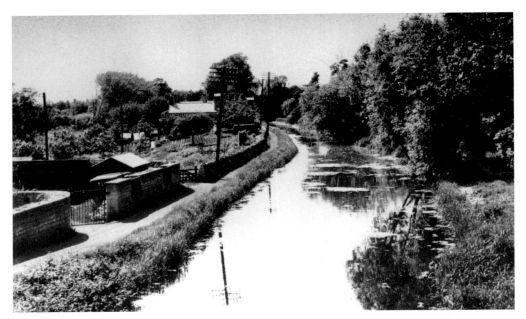

AT RYEFORD, *c.* 1930. The pound of the canal is described on the reverse of the original photograph as at Ryeford. We suggest its location was above Ryeford Double Lock and below Oilmills Bridge.

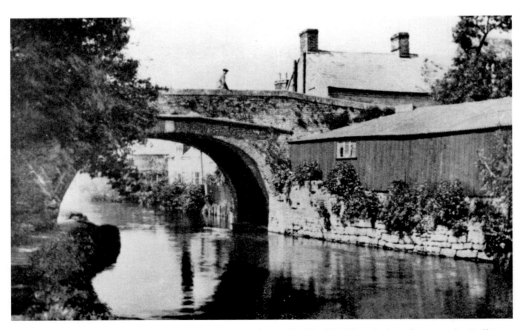

OILMILLS BRIDGE, EBLEY, *c.* 1920. This is also called Bell Bridge, being close to the Bell Inn. The roof of Ebley Sawmills can be seen through the centre of the bridge.

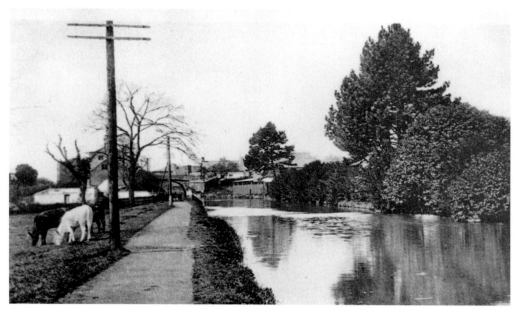

OILMILLS BRIDGE, EBLEY, *c*. 1915. A similar view to the previous picture, taken from the towpath opposite Ebley House.

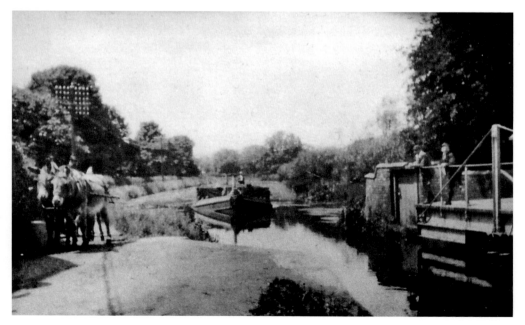

NEAR EBLEY SWING BRIDGE, *c*. 1920. The barge needing two donkeys for towing is a wide Stroudwater Barge. Often three donkeys or mules could be used to tow such a heavily laden barge.

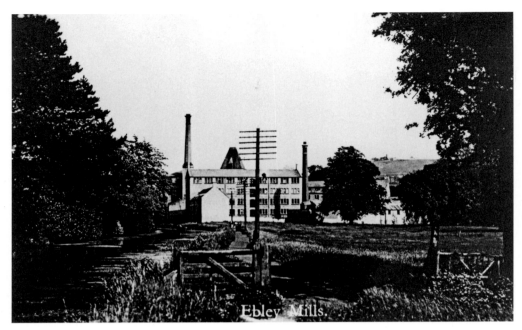

EBLEY MILLS (*c.* 1915), looking towards Stroud. The mills in the centre are now the headquarters of Stroud District Council. Note the well-known feature of Rodborough Fort on the skyline.

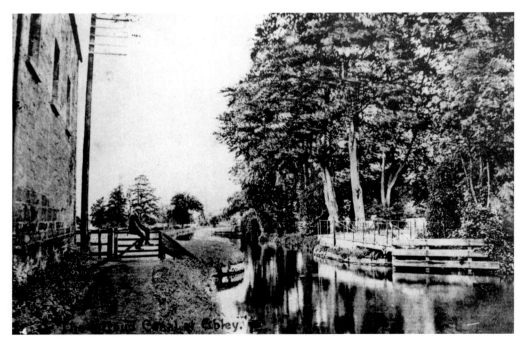

EBLEY MILLS SWING BRIDGE, *c.* 1905. Walk up the towpath of the previous picture to the first small building of the mill running parallel to the canal, turn round, and this would be the view where the canal narrows in front of Ebley Court.

ABOVE EBLEY MILLS *c.* 1905. Looking towards the mills from below Hilly Orchard Bridge at Cainscross. The typical summer use of many sections of both canals can be seen. Around forty years ago the canal from here to Wallbridge was narrowed to a stormwater channel and linked at this point into the adjacent River Frome.

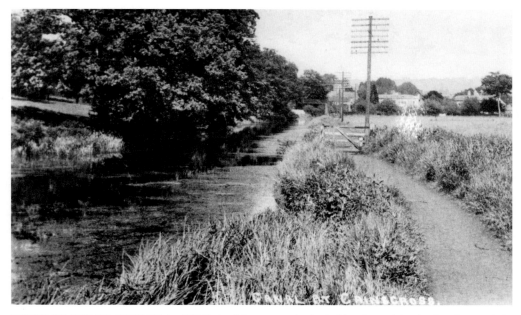

HILLY ORCHARD BRIDGE (*c.* 1920), looking towards the bridge (very faint in the distance). In the background are the industrial buildings at Dudbridge adjacent to the wharf. The photograph was taken at roughly the same point as the previous picture.

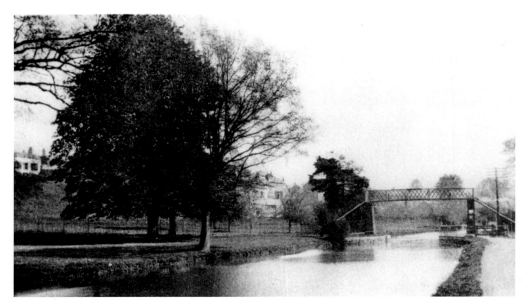

HILLY ORCHARD BRIDGE, 1913. In the 1960s this bridge was dropped off its pillars down to towpath level.

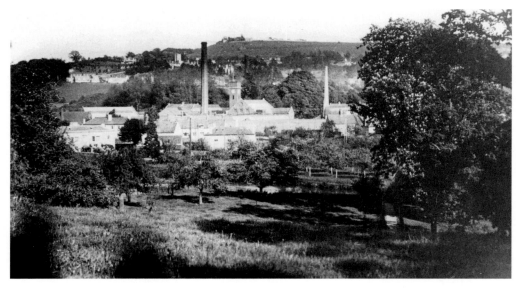

AT DUDBRIDGE MILLS, *c.* 1930. In this view from the Cainscross Road, the canal runs across the middle of the picture from Hilly Orchard Bridge to Dudbridge Wharf. Note the section of footpath in the trees on the right, leading to the bridge. The clocktower is a well-known feature of Dudbridge Mills, which were once the woollen mills of Apperly Curtis. For many years, however, from between the wars, they have housed Redler Engineers. Other industries also occupy the site, and in some buildings on the left, the Hampton Car Co. built their range of cars in the 1920s and early 1930s.

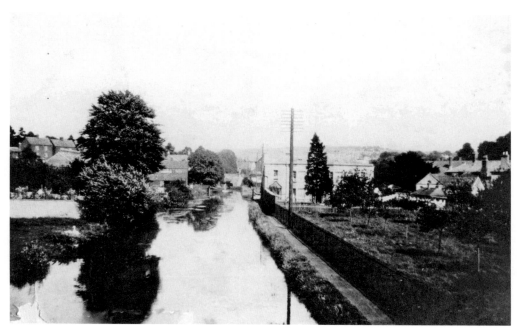

APPROACHING DUDBRIDGE WHARF, *c.* 1920. Just beyond the building on the right a barge, or trow, might just be seen moored at the wharf, with Dudbridge Bridge in the distance.

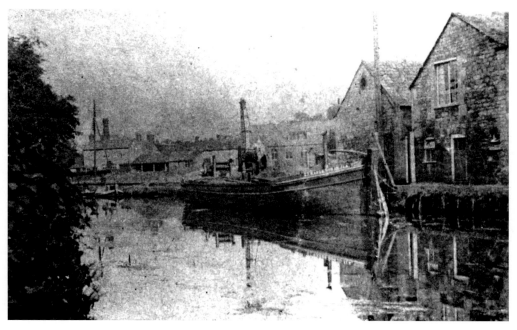

DUDBRIDGE WHARF, *c.* 1910. This is a view across the canal to the wharf. The moored barge was one of E. T. Ward & Co.'s boats. They were Stroud based coal merchants and carriers. The Wharfhouse and Warehouse are on the right.

Memorandum.

From **Henry Workman.**
Timber Merchant Contractor & Manufacturer.
Steam Saw Mills.
Woodchester, nr. Stroud.

April 2?

To Mr. Jas. Smar...
Chalfor...

Dear Sir / I have heard from my haulier at Newp...
morning, & he says he has quite blocked up the Do...
not take any more timber in until some of it has
removed. I shall therefore be glad if you will sen...
trow down at once, & bring up a cargo, ~~~ to Du...
Wharf as before. also please drop me a line by re...
& let me know when you expect to be there, so tha...
write my haulier & the wharfinger to oblige.

WORKMAN'S SAW MILL LETTER. A letter from Workman's at Woodchester to James Smart urging collection of timber by trow from Newport to Dudbridge Wharf. Haulage from there to Woodchester, which had to be arranged, could have been by horse-drawn timber wagons, or steam traction. Certainly twenty years later Workman's were using their own steam haulage, but at this time they may have been using Hawkes of Dudbridge.

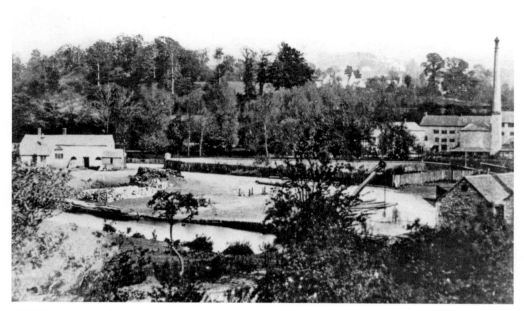

DUDBRIDGE WHARF, *c.* 1885. Note the wharf crane and various piles of goods. Compare Dudbridge Mills with the later complex, shown in the next picture.

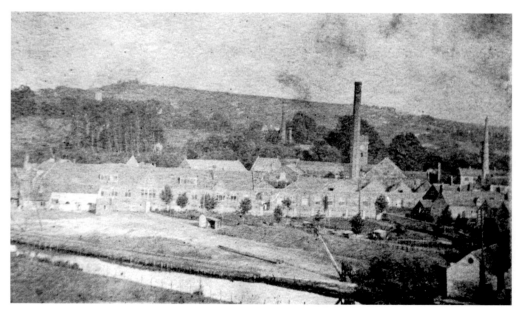

DUDBRIDGE WHARF (*c.* 1910), taken with a box camera from the bedroom window of a cottage in Bridge Street.

FROMEHALL (*c.* 1905), from Murder Lane across the canal, and from Fromehall Mill Pond to Fromehall and Rodborough. This section of the canal is just below the swing bridge which took Murder Lane across the canal to the mill and the Bath Road (A46).

Thames & Severn Canal

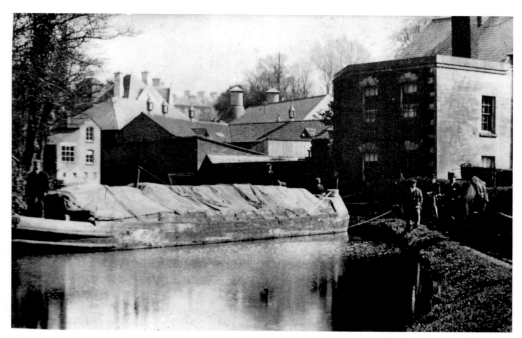

BETWEEN THE WALBRIDGE LOCKS, 1899. The Thames & Severn Canal was in need of urgent repairs in the mid-1890s in order to remain as a usable waterway. It was restored to 'fair working order' by the newly formed Thames & Severn Canal Trust in the late 1890s. The *Trial* was a local narrow boat owned by James Smart of Chalford and she was contracted to bring a cargo of wool from London to Stonehouse. The *Trial* is seen here on the sharp curve between Walbridge Upper Lock and Walbridge Lower Lock on the 11 April 1899.

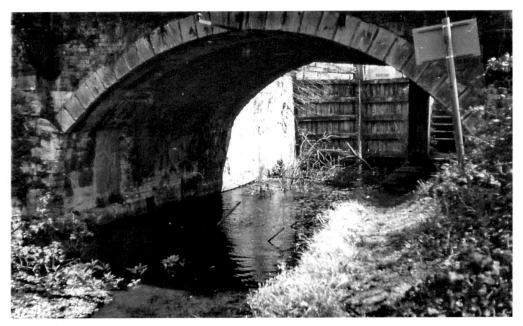

UPPER WALLBRIDGE LOCK, 1975. The canal left the Stroudwater Navigation from Wallbridge Basin terminus, passing through the Lower Wallbridge Lock, and then, curving sharply, passed under the Nailsworth turnpike road (later to become the A46 Bath Road) into the Upper Lock. Here the abandoned canal is shown where it passes under the bridge to the lower gate of the Upper Lock.

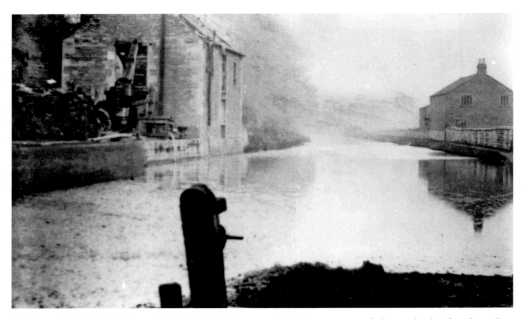

ABOVE WALLBRIDGE, c. 1885. The buildings on the left were part of the coal wharf and yard to the rear of the Bell Inn. The high wall and buildings on the right were also part of another coalyard.

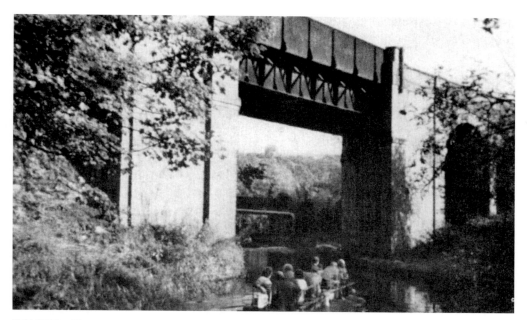

STROUD GWR VIADUCT, 1986. The canal from Wallbridge to Bowbridge was used in the 1980s for boat trips by the Canal Trust, generating funds for restoration work. Here a party is about to go under the Gloucester to Swindon railway viaduct and then the service road bridge on the last day before work started on the bypass which now leads under the iron bridge. A provision for the canal to pass under the new road to the right of the viaduct, to join the River Frome via an intermediate basin, was made, but it was not proceeded with by the County Council while the construction work was going on.

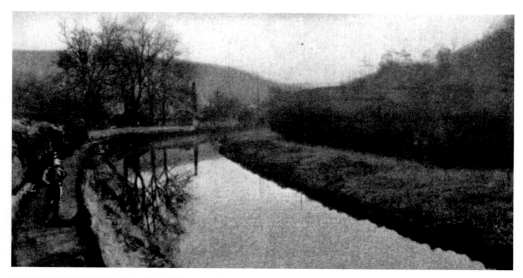

BELOW BOWBRIDGE, 1908. The canal approaching Arundels Mill on the left is about halfway between Stroud and Bowbridge.

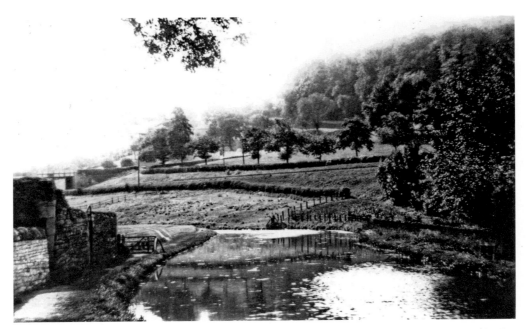

BELOW BOWBRIDGE, *c.* 1910. Beyond Arundels Mill the canal curves to run up to Bowbridge Lock parallel with the GWR, which runs across the centre of this photograph. Note the towpath gate. There were also gates at other locations and these gates were closed and locked once a year to make sure that the towpath did not constitute a permanent right of way.

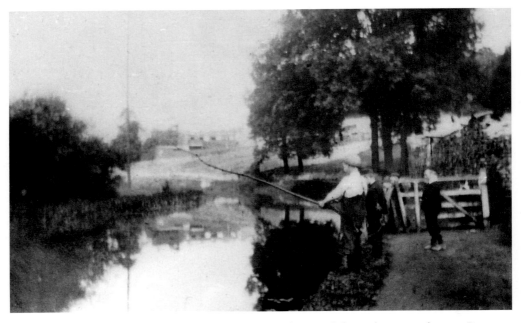

BELOW BOWBRIDGE, 1905. The view back towards Stroud from the towpath gate. Boys are busy fishing with a stick, thread and a bent pin.

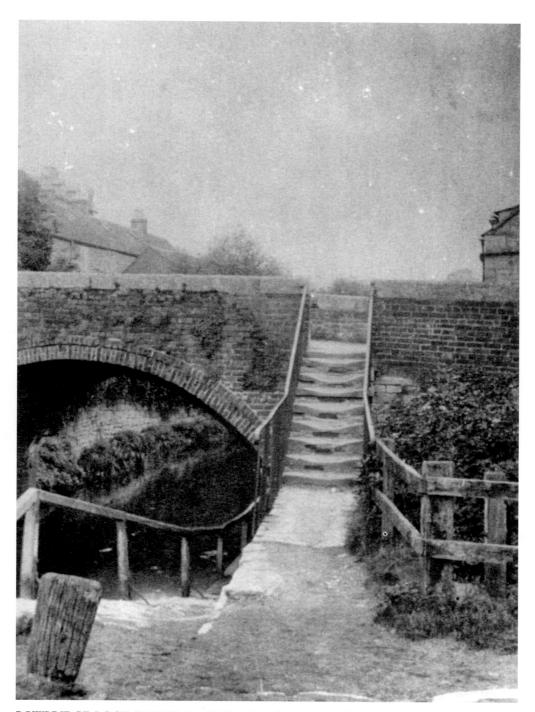

BOWBRIDGE LOCK BRIDGE (*c*. 1910), taken from the at the tail of the lock. The towpath drops left under the bridge, and well-worn steps rise up to the Minchinhampton road. To the right of the steps, the River Frome passes under the road.

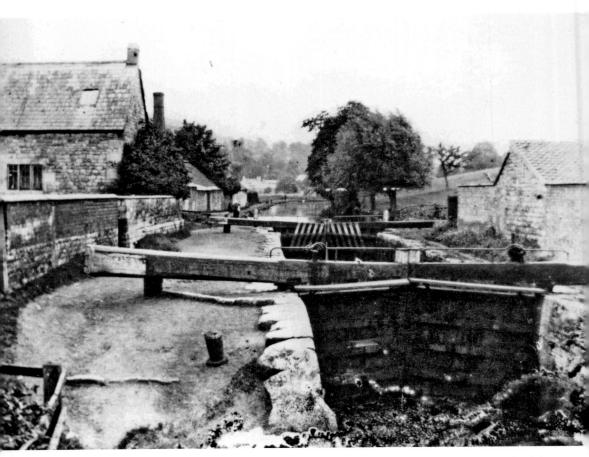

BOWBRIDGE LOCK (1908), looking east from the road bridge across the lock. On the left is one of the buildings of the complex of mills at Bowbridge. The site is now a modern housing estate. In the distance is Stafford Mills.

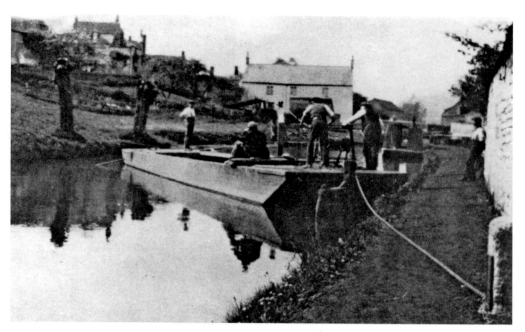

ABOVE BOWBRIDGE LOCK, *c.* 1910: the mud boat with the canal maintenance gang. One man appears to have done his stint, by the look of it.

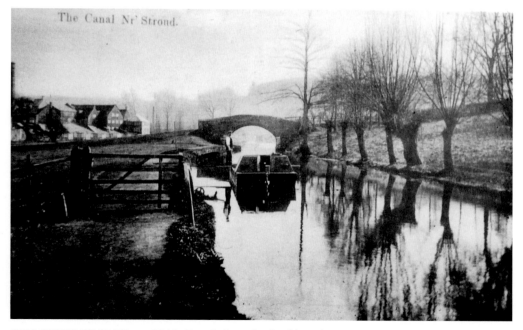

The Canal Nr' Strond.

STANTONS BRIDGE, *c.* 1910. Just below the bridge a barge is unloading. Note the plank connecting the boat to the towpath, so that goods could be unloaded and wheeled over to the mill. Most goods were transported, carriage paid, to the mill. Note Stafford Mills over to the left.

NEAR STANTONS BRIDGE, *c.* 1980. Here the canal pound runs down towards Bowbridge.

BELOW HAM MILL LOCK, *c.* 1910. Jubilee Bridge can be seen in the distance. Note the neatly thatched haystack in its fenced enclosure.

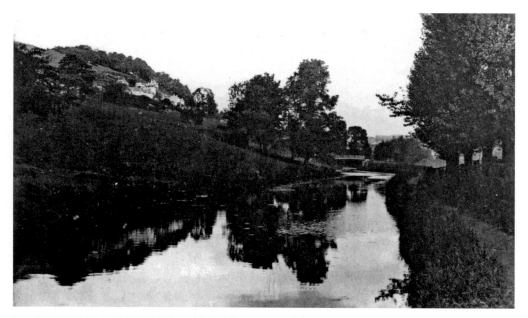

BELOW HAM MILL BRIDGE, *c.* 1915. Note some of the houses at Butterow on the hillside.

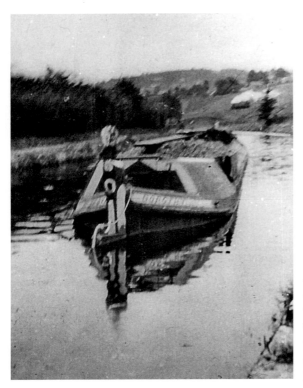

APPROACHING HAM MILL LOCK AT THRUPP, 1933. The last barge to take coal to Ham Mill is under way above Jubilee Bridge. Note the Gloucester to Chalford railcar, climbing between Ham Mill Halt and Brimscombe Bridge Halt.

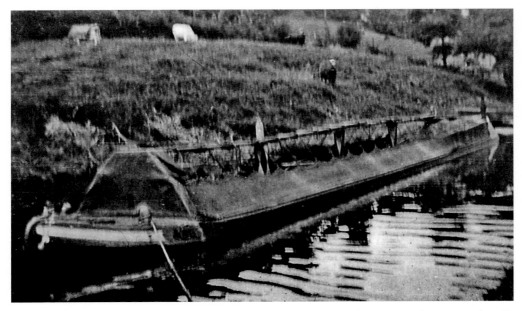

ABOVE HAM MILL LOCK, 1933. The last barge of coal is seen here, moored opposite the off-loading track into the mill just above Ham Mill Lock.

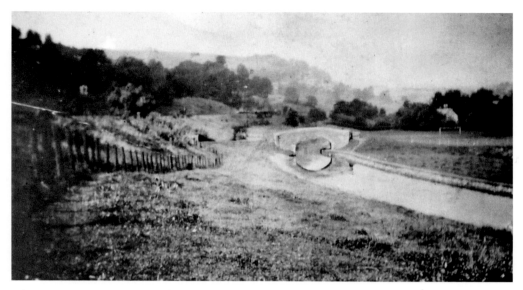

BAGPATH BRIDGE, 1943: the canal west from Hope Villa garden to Bagpath (or Phoenix) Bridge. This bridge was in danger of collapsing in the 1970s but was one of the first to be fully repaired by the Canal Trust. In the distance, to the left of the bridge, Ham Mill Halt can be seen. Note the goalposts of Thrupp football club in the field to the right.

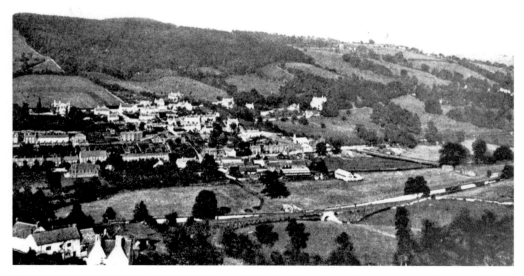

THE STROUD VALLEY AT THRUPP (*c.* 1910), looking from Bownham over Bagpath Bridge and the Phoenix Iron Works to Far Thrupp. When they were owned by John Ferrabee, E. Budding built the first lawnmower at these works. It is now in Stroud Museum. The small white building with the tall round chimney beyond the works was Smith's Brimscombe Brewery. The house (left, foreground) is Bagpath House.

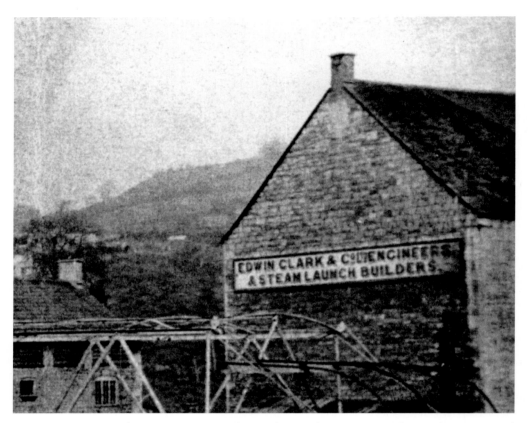

EDWIN CLARK was born in 1861 in Reading and entered engineering. After working at several engineering companies, he came to Thrupp in about 1883 and started an engineering business. In 1884 he built at least one steam launch and soon acquired the Canal Ironworks, an engineering works since about 1878. He was then able to start expanding the building of riverboats, not only for the rivers of this country but also for the Continent. Engines, boat fittings etc. were all manufactured at Hope Mill. After he acquired the Canal Ironworks, Clark built his home, Hope Villa, adjacent to it in 1887. He undoubtedly worked with Sissons of Gloucester, probably on a reciprocal basis for engines etc., and the business became known as Edwin Clark & Co. in around 1890. Unfortunately, Clark's health deteriorated and he died in 1896 aged only 35. He is buried in Brimscombe churchyard. His business was then turned into a limited company and Mr Earle was appointed Managing Director. A record of the Stroud District in 1898 lists the Limited Company as an 'Engineering, Yacht, Launch and Boat Building Works', which shows the extent to which Clark had enlarged his business. At the time three boats, one a 77-ft stern-wheeler, were on the stocks, indicating that it was a very busy yard for an inland situation.

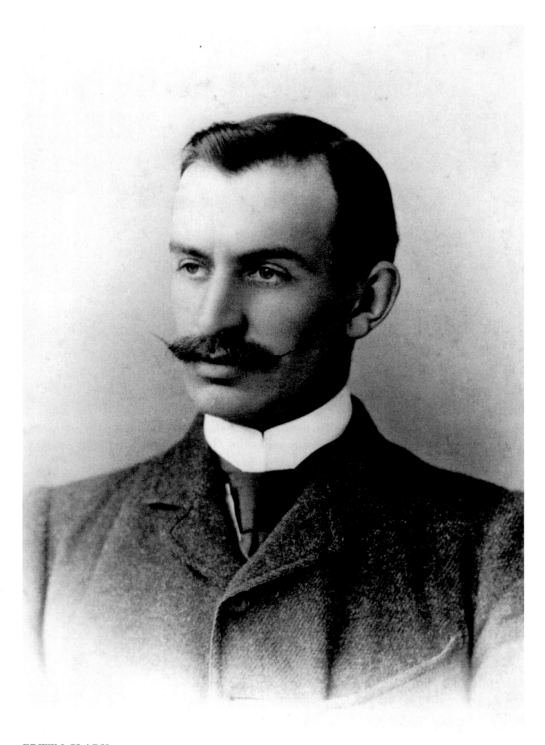

EDWIN CLARK.

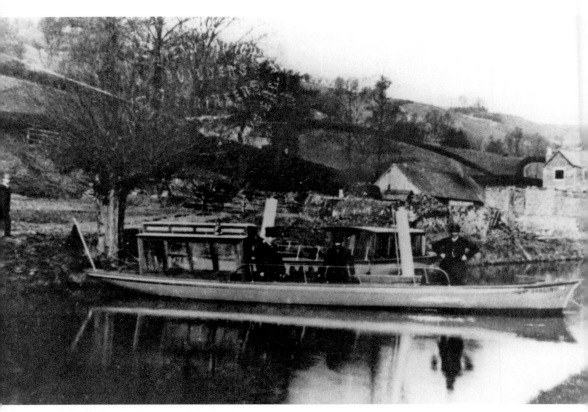

THE CANAL IRONWORKS, *c.* 1887. New sheds have been added and Hope Villa is under construction. The launch in the foreground is the *Darling*, built for Italian owners. Edwin Clark is the figure in the top hat facing forward. Only a portion of the name on the launch behind is visible, viz. THET – suggesting it was the *Thetis*. Also the cabin that is visible on this launch appears to be the same as that in the picture of the *Thetis* at the top of the next page, which indicates that the surmise is correct.

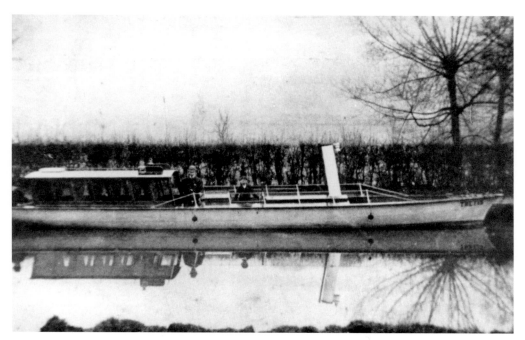

THE THETIS (*c.* 1887), on the canal between the Ironworks and Goughs Orchard Bridge.

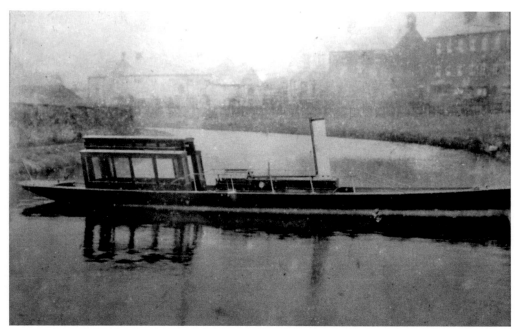

THE *DONOVAN*, *c.* 1889. This launch is moored across the canal, probably for the photograph, just west of the entrance to Brimscombe Port. The name is not visible, but the lines of the boat suggest it is the *Donovan*.

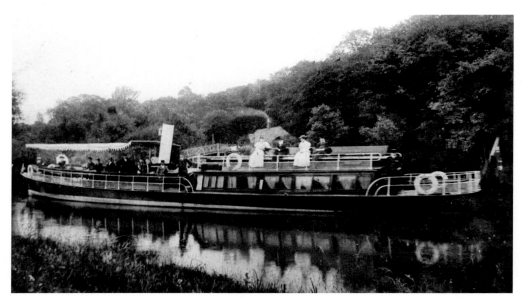

A SALTER STEAMER, *c. 1895*. One of the larger riverboats built by E. Clark for J.H. Salter of Oxford, who ran steamers down the Thames as far as Kingston. The name of the boat eludes us, but it is known that the yard built several 80-ft long boats for Salter that were too long for Thames and Severn locks. They were probably shipped in sections by trow to the Saul yards, and reassembled there.

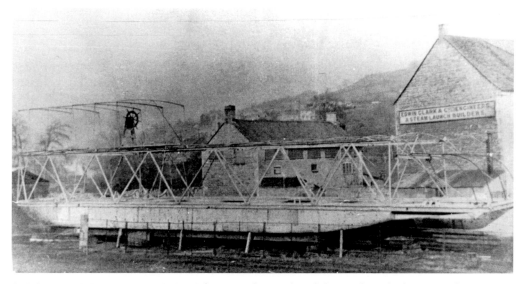

A STERN-WHEELER, *c. 1896/7*. A boat on the stocks of the yard, with the Limited Company sign on the end wall of Hope Mill. It appears to be a stern-wheeler, possibly similar to that mentioned in the article of 1898.

It is said that Edwin Clark & Co. Ltd's yard went into liquidation under Mr Earle's directorship in 1899, possibly through underfunding or less goodwill, as quite a few boats were built between Clark's death and the company's liquidation. There seems to have been little gap between Edwin Clark & Co. Ltd ceasing the business, and Abdella & Mitchell buying it. Perhaps Earle, who was a naval architect, managed the business while a buyer was found. In 1899 it was purchased by Abdella & Mitchell, who had a shipyard capable of building larger boats at Queensferry, and offices in Manchester. Orders flooded in, and by then the yard was very well equipped for all types of boat building, with slip-ways at the ironworks and full facilities for engine building, etc., at Hope Mill. Building boats for rivers on the Continent continued and during the First World War small boats were also built for the Admiralty. Many large two-deckers were built for South American owners, as well as fire floats, ferries and tugs. Large vessels were still shipped out in sections to the Saul yard or the Framilode yard and reassembled. Trials could have been in the area of the Severn at Framilode. After the First World War orders decreased and the yard temporarily closed in 1921. It resumed work in 1925. The canal was abandoned in 1933, making it impossible to send out any boats built by water. It is believed that a few went out by rail in sections from Stroud station on low-loaders (see page 50). Mr Frederick Suffall was the company secretary at the time and ran the firm until it was taken over by Air Plants Ltd. In 1937 he tried to get the County Council to restore the canal so that boat building could continue to provide employment, but the answer was that no funds were available.

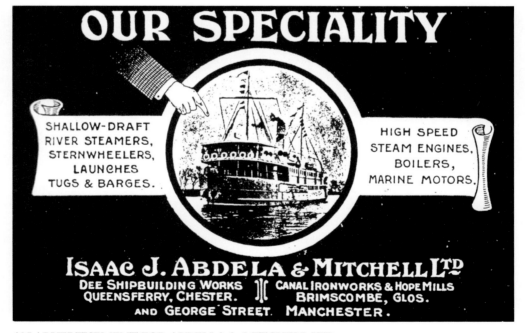

AN ADVERTISEMENT FOR ABDELLA & MITCHELL LTD.

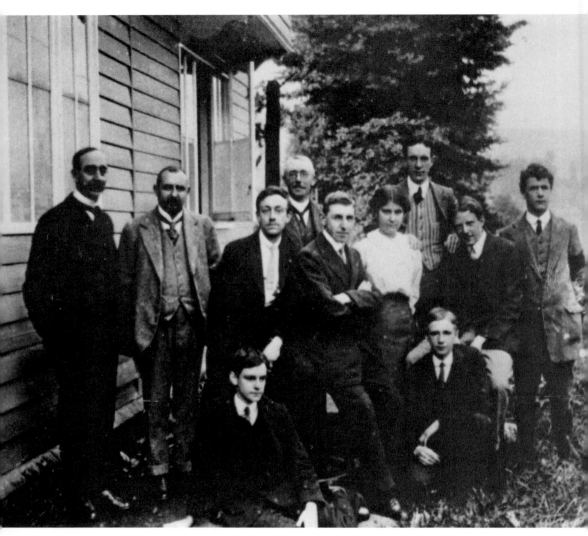

ABDELLA & MITCHELL STAFF, *c.* 1912. Back row, left to right: draughtsman (unidentified), John W. Earle (works manager), M. Knight (chief draughtsman), Harry Taylor (chief clerk), Ossie Merchant. Middle row: F.W. Baker, Ralph Ponting, -?-, -?-. Front row: Ernie Crook, Hubert Bloodworth. Hubert Bloodworth's father owned the foundry at Brimscombe South Mill, about half a mile from the yard.

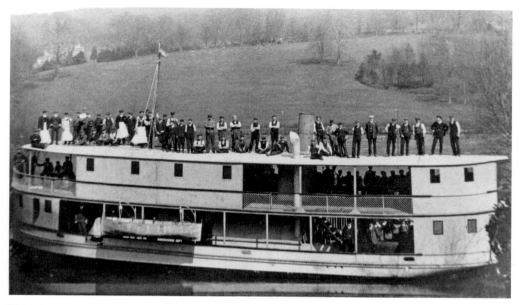

THE *SAN JUAN*, 1906. This was a two-decker on the canal by the yard, with the workforce abroad. Steering was in front of the cabin on the upper deck. Note the lifeboat.

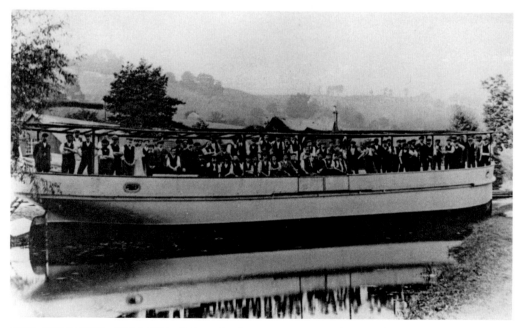

THE *HILDAGO*, 1906. This lighter is drawn up across the canal, with the yard in the background. It is possible that the workforce took every opportunity to have a photograph taken, but it is more likely that they were testing out the loading of the vessel.

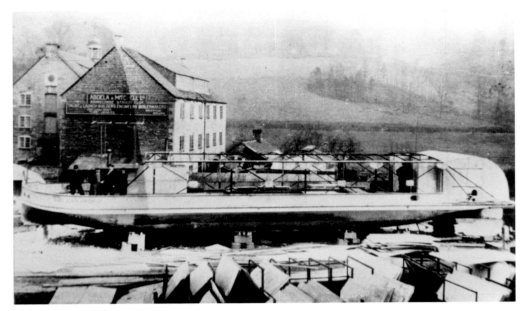

THE *JOAQUIM CRUZ, c.* 1907/8. This stern-wheeler is on the stocks, with Hope Mill in the background. Note the plates stacked in the yard. Behind the group, in the bows, is a lean-to shed joined to the mill. This was built onto the towpath and housed a portable engine, which drove a shaft through the wall for running lathes, etc.

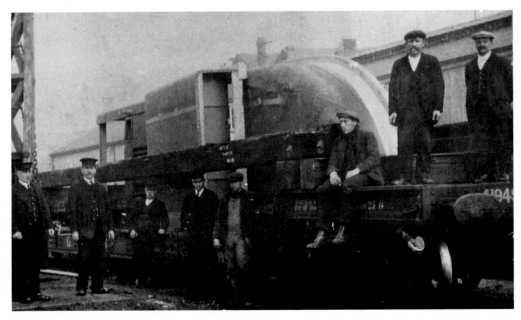

A LARGE BOAT SECTION being moved by rail, *c.* 1920. As already mentioned, some of the boats built at the yard were too wide to navigate the canal. This picture shows part of such a boat on a low-loader railway wagon, being moved from Stroud by rail.

BRIMSCOMBE ROAD BRIDGE (*c.* 1915), from the towpath opposite the Ship Inn. Note the barge moored by the left-hand towpath, where it connects with the main road opposite the Port Inn. The tall building in the distance was Brimscombe Polytechnic at this date. The gas main has been fixed to the bridge, and there was another pipe on the far side.

BRIMSCOMBE BRIDGE, 1911.

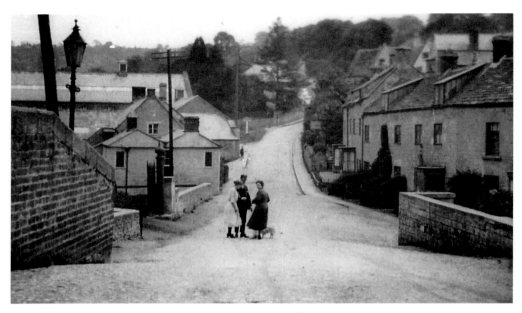

BRIMSCOMBE HILL, *c.* 1920. This looks up the hill from the bridge, with the parapets on either side. On the left are cottages and buildings connected with Port Mills. The road to the left by the signpost leads to the Canal West Wharf.

BRIMSCOMBE (*c.* 1920), looking north towards the bridge. The road to the left of the horses and cart leads to the Ship Inn, and to the 'up' platform of Brimscombe Bridge railway halt. Mr Ernest Barrett, captain of Brimscombe fire brigade, lived in the cottage on the right.

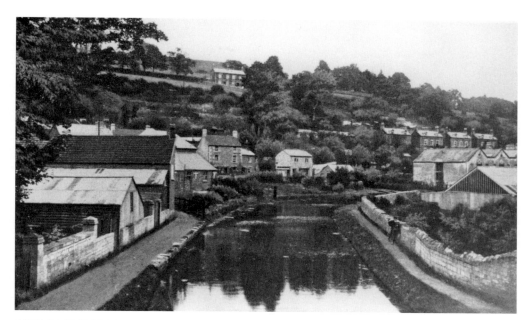

APPROACHING BRIMSCOMBE PORT (*c.* 1907), looking east to the port, showing the two canal towpaths. The left-hand path ran to the main road alongside Brimscombe Co-op Stores, and the white-roofed lean-to section was the warehouse of the store.

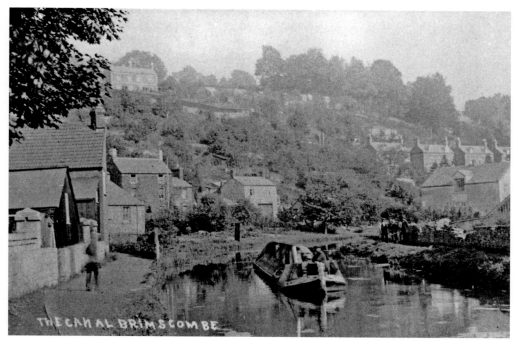

APPROACHING BRIMSCOMBE PORT, 1915. A barge is under tow by a horse moving towards the port entrance.

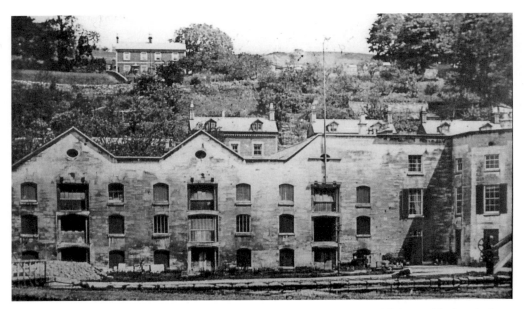

THE THAMES & SEVERN HEADQUARTERS BUILDING, *c.* 1910. This would already have served for twenty years as Brimscombe Polytechnic, during which time repeated pleas to convert and renovate the building for use as an educational centre had been made to the County Council. In around 1908 the council sanctioned the work, and in this picture the conversion is taking place. The section on the right was the Principal's office and house. The canal was run from the Stroudwater headquarters at Wallbridge.

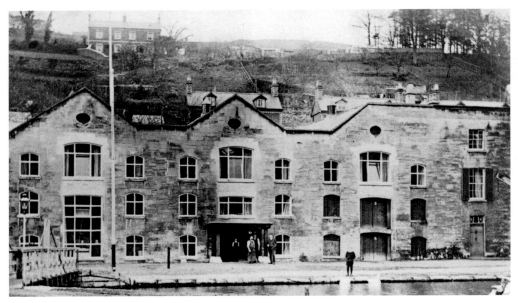

BRIMSCOMBE POLYTECHNIC, 1911. The conversion is now complete. The photograph may have been taken prior to the official opening ceremony on 5 October 1911 by the Duchess of Beaufort.

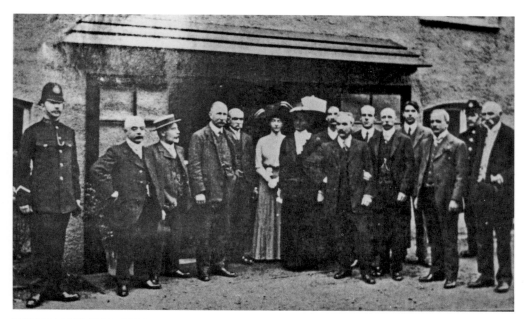

THE REOPENING CEREMONY at Brimscombe Polytechnic School, 5 October 1911. Officials and friends at the ceremony are, left to right: P.C. McKnight, A.W. Hook, U. Hook, L. Grist, T. Weaver, Miss Massey, Mrs E Aikin-Sneath, J.H. Smart, W.L. Randall, H.S. Evans, E.E. Evans, E.C. Chivers, E.C. Aikin-Sneath, P.C. Neale, F.E. Critchley. Of these people the Hook brothers carried out the alterations to the buildings, J.H. Smart was a barge owner at Chalford, E.E. Evans the founder of the Polytechnic, and F.E. Critchley from Wimberley Mills its Chairman.

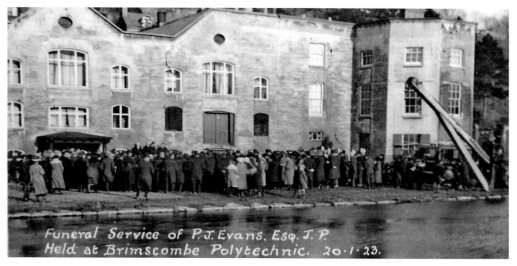

Funeral Service of P.J. Evans. Esq. J.P.
Held at Brimscombe Polytechnic. 20·1·23.

FUNERAL OF P.J. EVANS at Brimscombe Polytechnic, 20 January 1923. The Evans family owned the Brimscombe Port Mills to the west of this building. Note the large wooden crane on the north quay in front of the former Thames & Severn Canal Headquarters building.

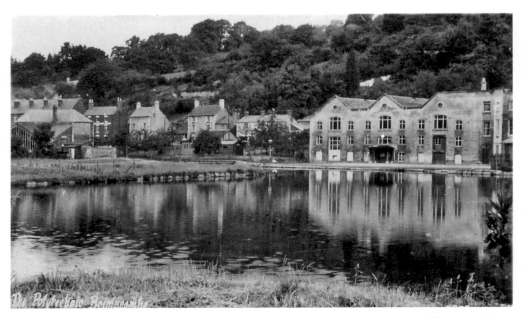

BRIMSCOMBE PORT, *c*. 1930. Minor alterations have been made to ground-floor windows. The large building (centre left) is the Co-op stores, partly obscuring the Port Inn to its right. Over its roof is the roof of Gordon Terrace, once a silk mill and now converted to houses and shops. Note the cultivated garden of Wharf Cottage on the left.

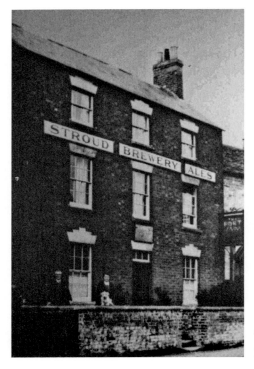

THE PORT INN, *c*. 1920. One of three public houses in close proximity to the port.

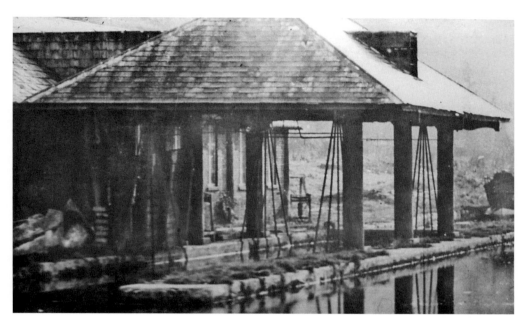

THE BARGE-WEIGHING MACHINE, *c.* 1920.

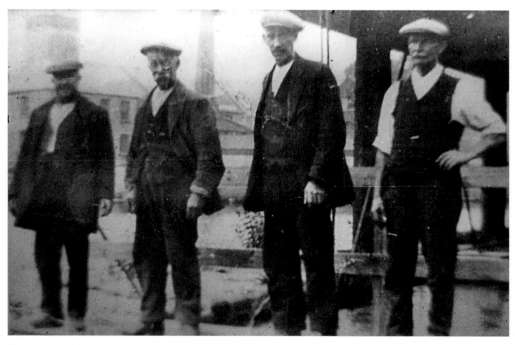

THE DISMANTLING OF THE BARGE-WEIGHING MACHINE, 1937. The machine adjoining the north quay to the port is shown in the top view but it is in a very disused condition. The gang who dismantled it are pictured here. Its members may have posed before work commenced. Left to right are: Alf Collins, Tom Dowdeswell, Ernie Crook, Henry Stephens.

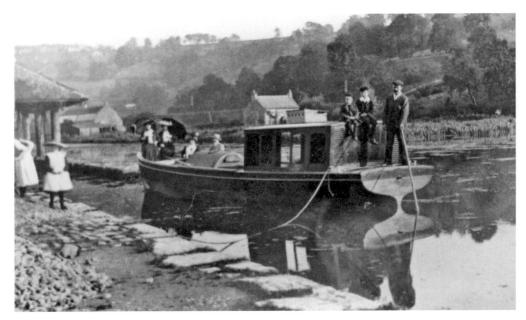

IN BRIMSCOMBE PORT, c. 1905. An Abdella & Mitchell launch is moored by the north wharf, by the barge-wielding machine shed. In the distance, to the right of the shed, is Island Warehouse. South Warehouse is beyond the launch. By this time the latter was a private cottage.

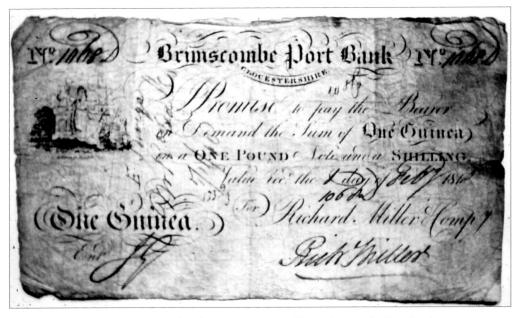

A GUINEA NOTE, 1818. These bank notes were issued by Brimscombe Port Bank.

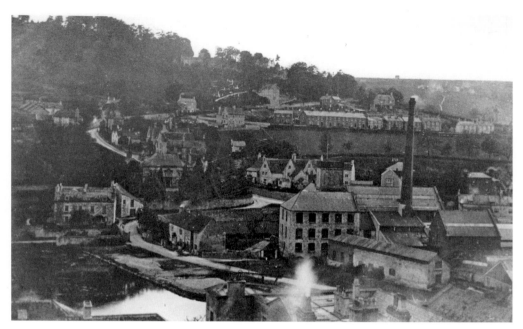

BRIMSCOMBE PORT WEST WHARF AND PORT MILLS (*c.* 1905), looking south to Brimscombe Hill and the road to Minchinhampton Common (the treeless area on the right skyline). The row of buildings on the hillside is on the south side of Victoria Road, the tall building above the first row on the left being Brimscombe School. There appears to be little activity on the wharf, but at this time the canal above the port would have been undergoing extensive restoration by the County Council, which would have limited traffic.

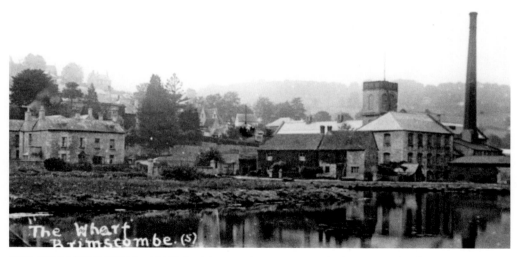

BRIMSCOMBE PORT (*c.* 1920), looking south-west across the basin to Wharf Cottages and the salt store. Note the small cottage on the left of the main cottage, covered in ivy.

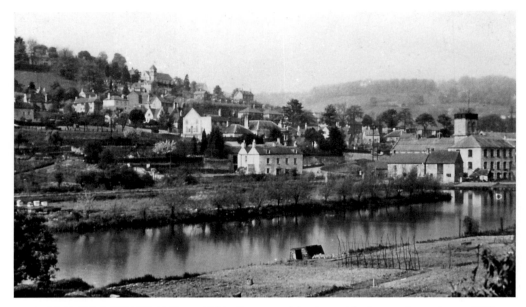

BRIMSCOMBE PORT ISLAND, *c.* 1939. Compare this view with the previous picture. Willows are growing on the north side of the island, where a beekeeper now has a few hives. The cottage and store have had the creeper removed. Brimscombe church, endowed by Col. Ricardo of Gatcombe Park, is prominent on the hill. Edwin Clark (see page 42) is buried in the churchyard.

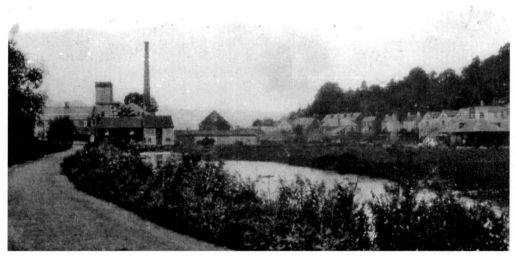

BRIMSCOMBE PORT ISLAND (*c.* 1920), from the south road/towpath towards Wharf Cottages and Port Mills. It was probably taken from the cottage, formerly the South Warehouse (see page 58).

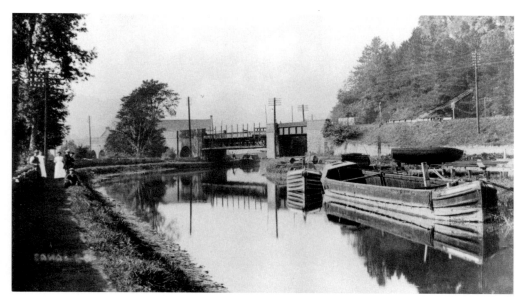

BOURNE BOATYARD and railway bridge, *c.* 1900. A lovely working photograph of the canal with the entrance to the Bourne Boatyard on the right with moored barges etc. showing work in hand at the yard. There is a posed group of people on the towpath to the left. At this point the canal and towpath have been culverted and the iron bridge has been underfilled.

BOURNE BOATYARD, *c.* 1905. Looking north-west over the Dark Mills, there are barges moored by the dry docks of the boatyard. This yard was established by the Thames & Severn Co. to build ships and barges for company use on the canal. Samuel Bird was the first shipbuilder to be employed there by the company.

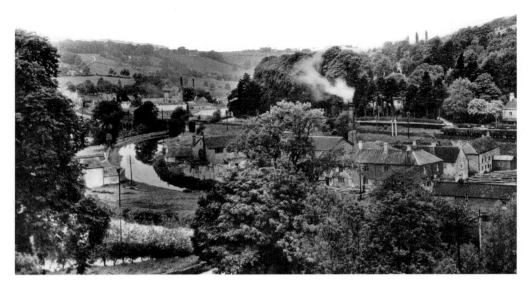

THE BOURNE, *c.* 1910. South-west from the Knapp is the curve of the canal as it passes Bourne boatyard. The entrance to the Wimberley Mills of Critchley Bros. is in the foreground. The buildings in the centre are the Bourne sawmills of Philpotts. Since the Second World War they have been the works of the Olympic Varnish Co.

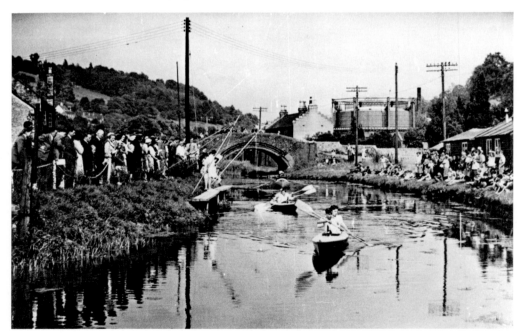

BY BRIMSCOMBE GAS WORKS, *c.* 1950. Canoe activities alongside the present-day site of the Olympic Varnish Co. It is possibly a school or scout function. In the background is the gasometer of Brimscombe gas works.

A CRITCHLEY BROS. letter, 1886.

A CRITCHLEY BROS. LETTER, 1887. These two letters are to James Smart, asking for quotations for coal deliveries.

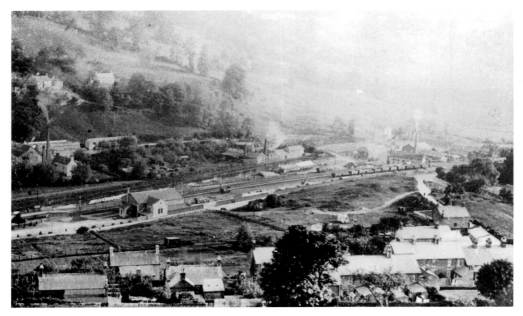

A VIEW ACROSS THE VALLEY from Brownshill Bank (*c.* 1900), looking across the canal and Brimscombe station to Wimberley Mills. At the centre of the picture is Brimscombe gas works. The rough area to the north of the road had been used for brick manufacture. Housing dating from the early years of this century now covers the site.

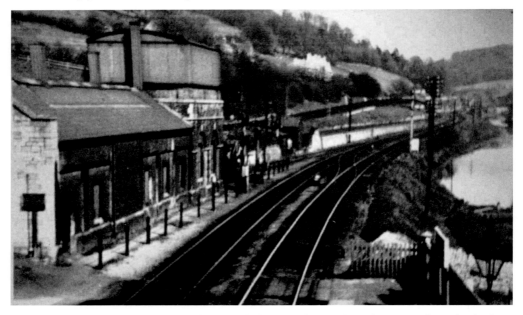

BRIMSCOMBE STATION, 1932. The pound above Beale's Lock is shown on the right, looking towards St Mary's. This section of canal was always kept full of water and comparatively weed-free, as water was drawn from it for the railway banker-engine shed tank.

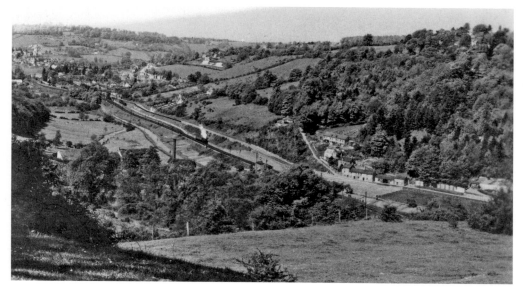

AT ST MARY'S, Chalford (*c.* 1930), looking down the valley from Hyde Hill towards Brimscombe. It shows how close together the road, railway, canal and River Frome were. They all ran parallel to each other through the valley as it began to narrow through Chalford.

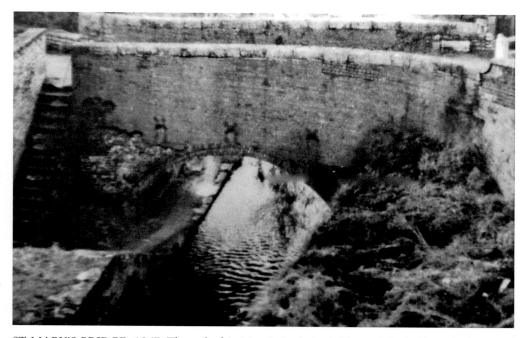

ST MARY'S BRIDGE, 1967. The tail of St Mary's Lock is visible, and the bridge which carried an accommodation road into St Mary's Mill from the main road.

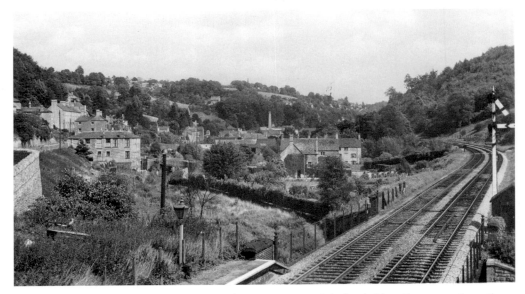

ST MARY'S AT CHALFORD (*c.* 1950), from St Mary's Halt footbridge. East over the railway bridge is a section of the abandoned canal towards Iles Bridge and Lock (middle left). Beyond is Ballingers Bridge and Lock. This section is now a weed-choked channel.

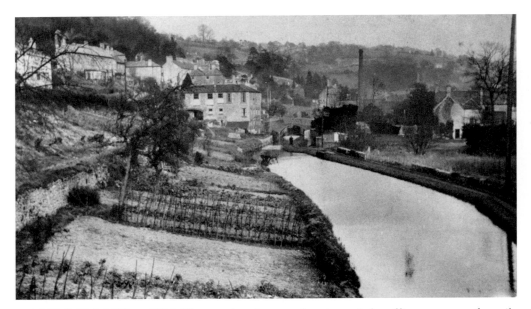

BELOW ILES LOCK, c. 1925. The canal as it was when it carried traffic a quarter of a mile further, towards Chalford Wharf and Roundhouse. Clayfields Mill to the left of Iles Bridge, and the chimney of Ballingers (also Clarks, Belvedere or Chalford) Mill, are to the right.

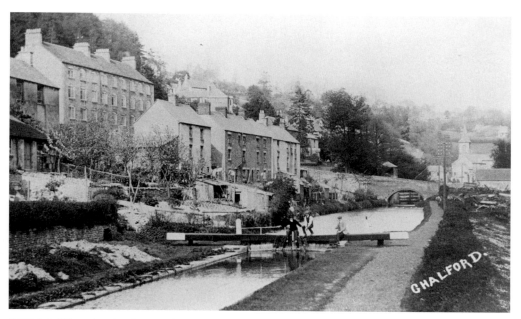

ILES LOCK, *c.* 1910. The canal towards Ballingers Lock is seen here as a working waterway in excellent condition after the County Council restoration. The houses on the left were demolished in the 1960s for road widening.

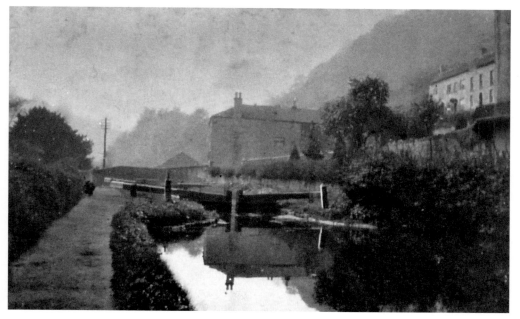

ABOVE ILES LOCK, 1910. The reverse of the previous picture, looking towards Iles Lock with Clayfields Mill to the right of the bridge.

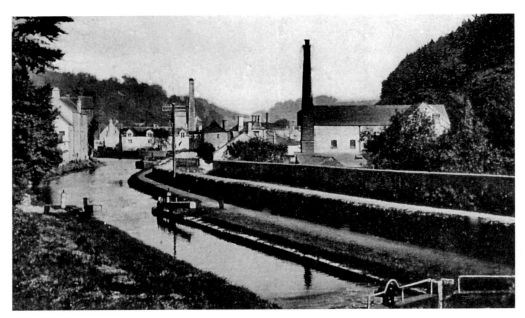

BALLINGERS LOCK, *c.* 1910. Looking from Ballingers Bridge towards the Roundhouse and wharf, we see Ballingers Mill on the right. James Smart's house, Greystones, is immediately beyond the roundhouse to the left. One of his barges is moored on the right.

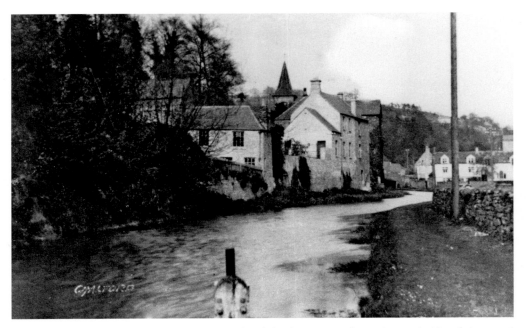

ABOVE BALLINGERS LOCK, 1910. Details of the houses on the main road side of the canal are visible. The house in the centre was Chalford Police Station, containing two cells. All the canal-side buildings were demolished for road widening in the 1960s.

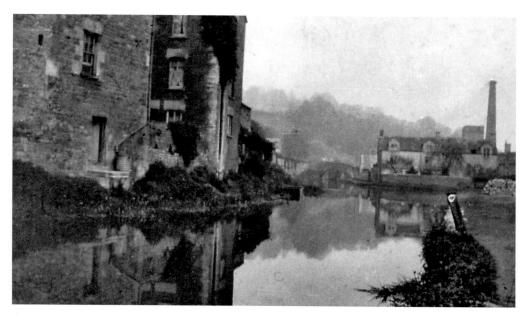

APPROACHING CHALFORD WHARF, 1910. Note the canal-side door in the Police Station and the small landing stage. On the right is the wharf and Greystones, with Chapel Bridge in the distance.

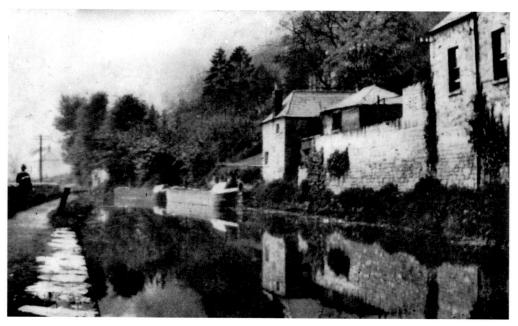

CHALFORD WHARF, 1910. The reverse view of the previous picture, showing barges moored west of the Police Station. Note the wooden double gates at the entrance to the wharf.

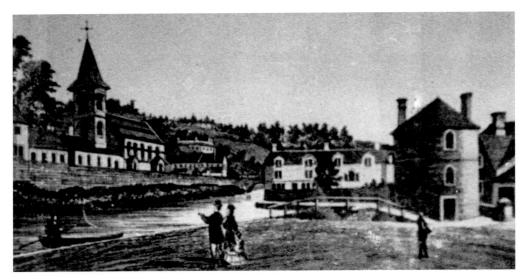

CHALFORD WHARF, 1840. A print of the wharf, roundhouse, Greystones, Chapel Bridge, canal and Chalford church. The church is seen in its new form, after its enlargement and renovation from a chapel of ease. The portion surrounding the base of the tower was removed in 1870, and the bridge gained its name from the original chapel of ease.

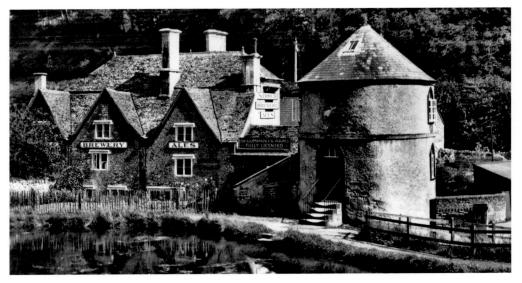

CHALFORD ROUNDHOUSE, c. 1940. The first of five roundhouses to be built as lengthmen's cottages between Chalford and Inglesham, Chalford Roundhouse was a four-storey building with stables in the basement, a living room, bedrooms and attic rooms. This one housed at least ten people in one family at one time. The Company's Arms behind is one of the oldest houses in Chalford and some parts are medieval. In the early nineteenth century the proprietor ran coaches to London, Bristol and Gloucester. The 'Company' acknowledged the involvement of Chalford's woollen industry with the East India Company. The inn closed in 1964.

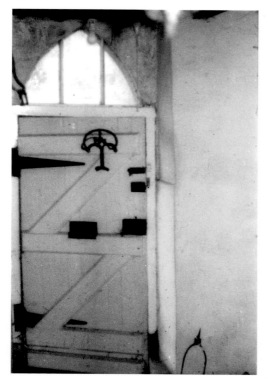

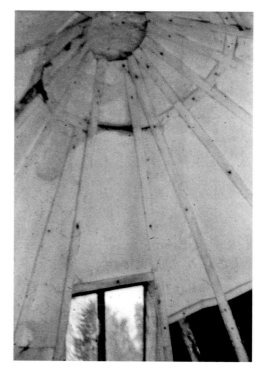

Above left: inside Chalford Roundhouse, *c.* 1970: detail of the rear of the main front entrance door.

Above right: inside Chalford Roundhouse, *c.* 1970: the access ladder up to the room under the conical roof.

Right: inside Chalford Roundhouse, *c.* 1970: detail of the timbers of the conical roof.

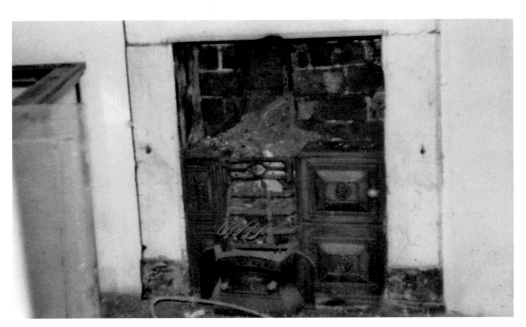

INSIDE CHALFORD ROUNDHOUSE, *c.* 1970. The living room fireplace is shown before the renovation of the building to a dwelling house. The grate is typical of many which could still be found in Chalford cottages before the last war.

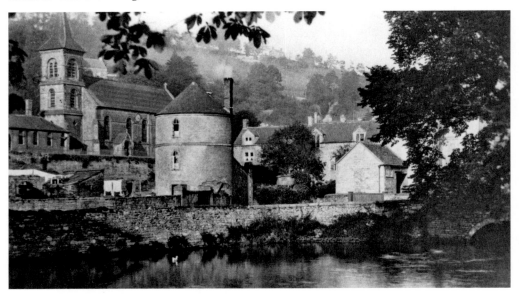

CHALFORD CHURCH AND ROUNDHOUSE, *c.* 1925. Across Belvedere Mill pond is the Roundhouse. Also shown are the canal and the main A419 in front of Chalford church. A lengthman still lived in the Roundhouse at this date. The stucco rendering characteristic of all the roundhouses along the canal is visible. The renovation of this one involved the removal of all stucco, which was replaced with pointing.

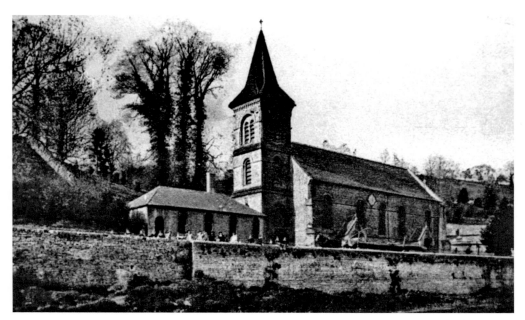

CHALFORD CHURCH, *c.* 1905.

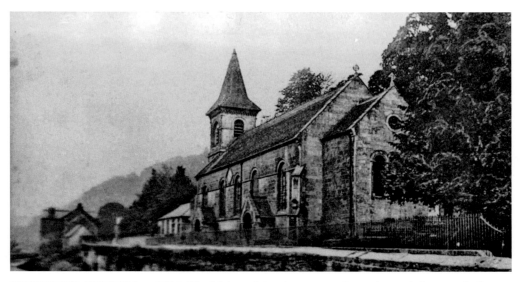

CHALFORD CHURCH, *c.* 1910. The high wall (top) supports the main road that was built as a turnpike in 1814/5. It is still there, buried under the widened A419. The occasion appears to be the start of a Sunday school outing. The support wall also appears in the photograph below. The two low buildings were the blacksmith's shop of W. Taysum. The one beyond was a storehouse on the ground floor and a meeting room above, which became the Chalford WI room in the 1920s. The house at right-angles was privately owned. One room was used as a doctor's surgery; beyond that was the Police Station.

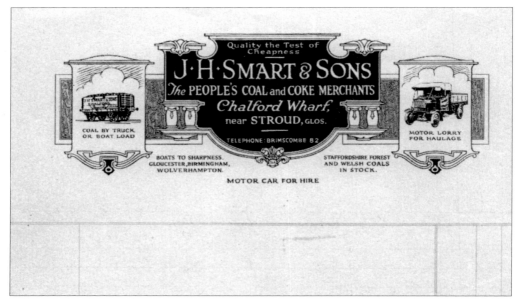

A JAMES SMART LETTERHEAD. Although headed J. H. Smart this letterhead is from the period when his son Harry was running the business during the twentieth century.

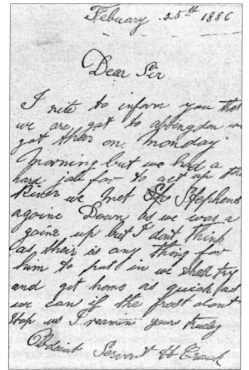

Left: Bargee's letter to James Smart, 1886.

Opposite: Bargee's letter to James Smart, 1887. These letters are written as they would have been spoken, in the Gloucestershire accent. They would have been delivered to Chalford on the day they were written, or on the following morning, and any money requested would have been sent to each of the bargees the next day.

1889

Sir this will inform you
that when i was at wallingford
a man had a donkey for
sale and he wanted 3 Pound
for him so i made a
Chop with sam so i have
not got ony money now
please to send me one pound
ten shillings by return of
post to wantage as i shall
get theare on thursday
morning yours truely
Frank Pearce

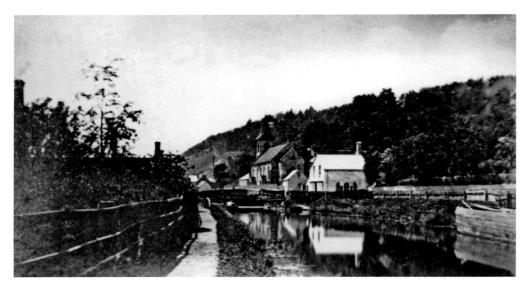

THE POUND ABOVE CHAPEL LOCK, *c. 1875*. The strip of land above the lock and between the road became Couldrey's Wharf. The white-roofed house had connections with Sevilles Lower Mill behind it. The small building between it and the church was originally a pikehouse, where the road from Bisley met the main road to Stroud. The orchard area to the left of the towpath was part of Bliss Mills.

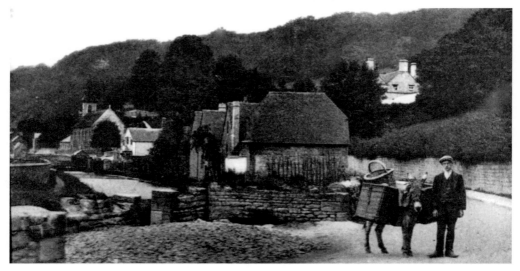

GCC ROADSTONE WHARF, *c. 1912*. The wharf now has a building on it, and one of Chalford's bread donkeys stands by the area to which barges brought loads of stone for use on the main road to London. The buildings visible on the right are the house, stables and coach-house of Wickham Grange (formerly Beaumont House). William Dangerfield once lived there; he was the owner of Bliss Mills, where he carried on a walking-stick and wood-working business employing 1,000 hands in the 1880s.

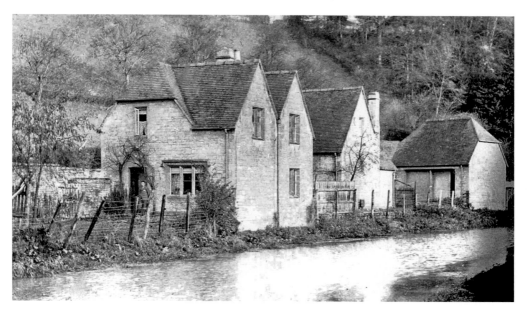

THE COACH-HOUSE AND STABLES, *c.* 1912. At this time the house was the home of William Taysum, Chalford's blacksmith. The stables etc. were used by Chalford Co-op stores. The view is from the canal towpath.

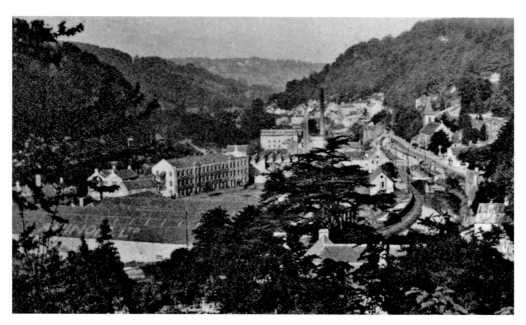

CHALFORD VALLEY FROM POOLES GROUND, *c.* 1933. Looking west down the valley it begins to narrow, squeezing transport arteries together. Bliss Mills on the left were just beginning to recover from the depression, as shown by 'Laminoid Ltd' on the roof of one building. It was the forerunner of Fibrecrete Ltd, a cement/asbestos products firm.

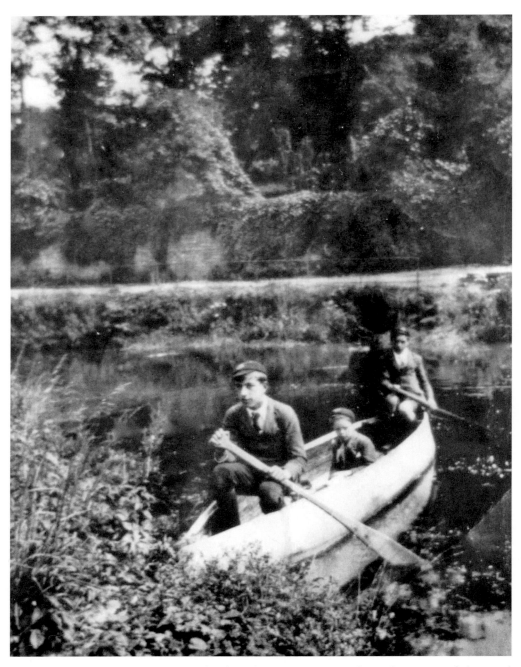

BELOW BELL BRIDGE, *c.* 1920. The three boys canoeing on the wide section of the canal below the bridge are from Wycliffe College. Two are known: in front is Jack Smart, the son of Fred Smart who kept the general store in Chalford High Street and was Registrar for the Bisley Division; the small boy is Leo Waals, son of Peter Waals, furniture-maker at nearby Hallidays Mill.

BELL BRIDGE, 1932.

BELL BRIDGE, 1933. The bridge was at the bottom of Cowcombe Hill and is shown in the top view in its original form. In 1933 the Gloucestershire County Council reconstructed the bridge when they straightened out the sharp corners over the bridge. Bell Lock is immediately off to the left and Hallidays Mill is behind the tree by the man. The stone pillar to the right marks the entrance to Springfield House. The lower view shows the reconstruction and realignment of the road.

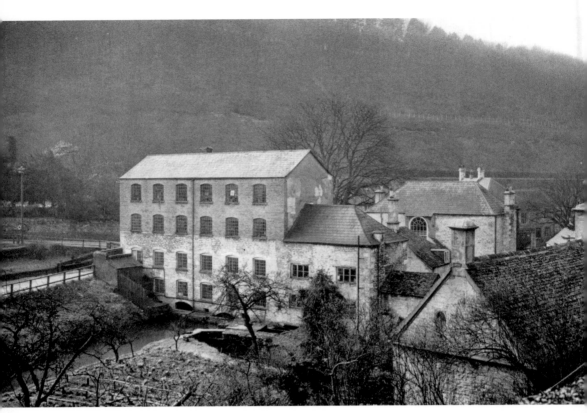

HALLIDAYS MILL (*c.* 1920), from the High Street. Immediately to the left is the canal towpath and the beam of Bell Lock can just be seen parallel to the path. Hallidays Mill, originally Smarts Mill, was a woollen, then a silk mill. It was unused by 1910. In 1912 the road level floor was opened by Countess Bathurst as a meeting room for the Primrose League, and it was used to pack parcels for the troops in the First World War. In 1920, after the death of the renowned Sapperton craftsman Ernest Gimson, his foreman, Peter Waals, moved the workforce of highly skilled furniture makers to this mill and lived in the adjoining mill house, called Chestnut House, until his death in 1937. A branch of the Halliday family emigrated to America where they were renamed Holliday. Doc Holliday was a famous descendant.

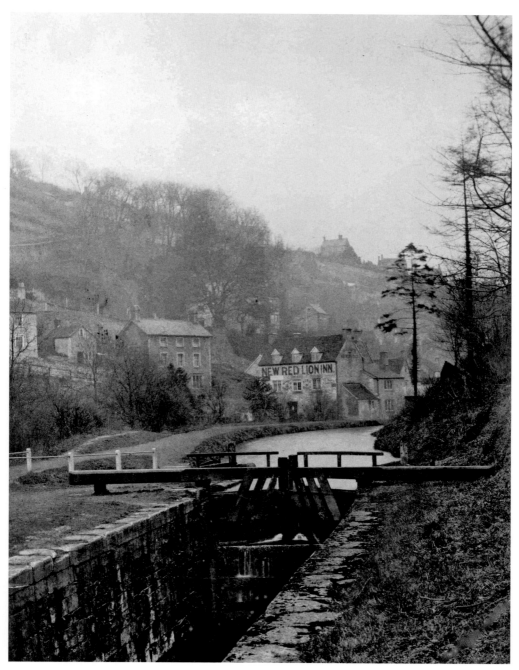

BELL LOCK, 1905.

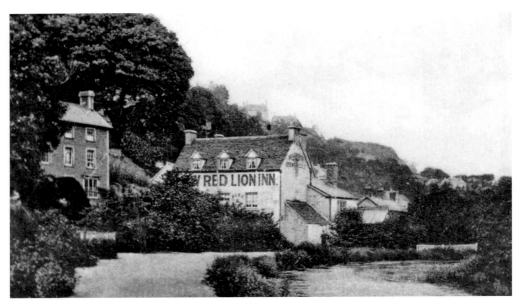

ABOVE BELL LOCK, *c.* 1910. The entrance on the left is to the footpath leading to the High Street and the Bell Inn. It crossed the River Frome by a small bridge leading into the Bell Inn's gardens.

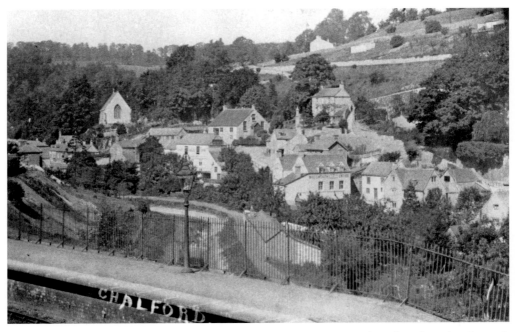

CHALFORD STATION (*c.* 1920), looking across the station to Rack Hill and Pooles Ground, with the canal empty. In the centre is the New Red Lion Inn and to its left, framed by the trees, is the Bell Inn. Both of these inns were the haunts of bargees. The long low building alongside the towpath is the Red Lion's skittle alley.

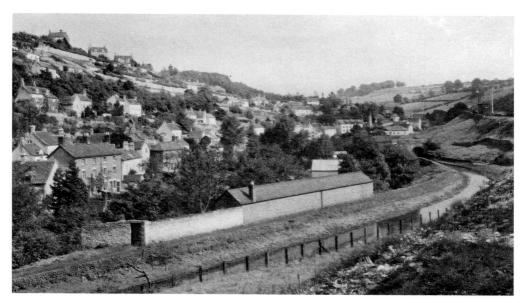

APPROACHING CLOWES BRIDGE (*c*. 1920), seen from the west end of the station yard. There are railway gangers at work on the track near the station siding point.

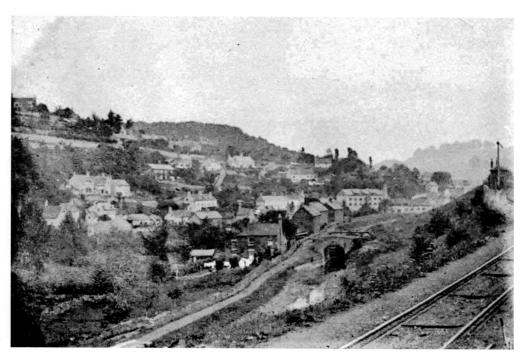

ACROSS CHALFORD RAILWAY SIDING, *c*. 1925. From the east end of the station yard can be seen Clowes Bridge and lock gates with an overgrown canal bed beyond. The mill in the background is Sevilles Mill which was demolished in 1952.

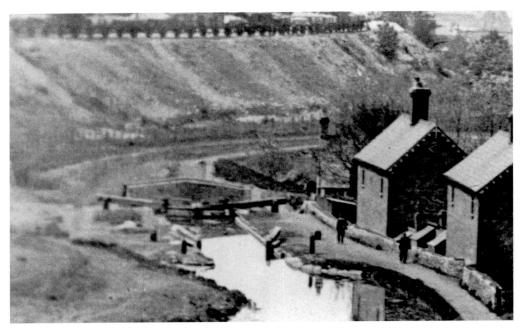

CLOWES LOCK (*c.* 1905), showing a full lock from the east. The bridge took an old track across the canal from the High Street, up to the hill over what was to be the railway track to Cowcombe Hill, and on to Minchinhampton. The cottages on the right are Meadow Cottages, built about thirty years previously.

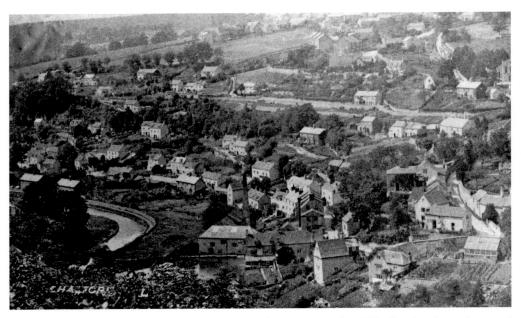

LOOKING OVER SEVILLES MILL (*c.* 1910), from Cowcombe Hill, showing how the canal sweeps round to the narrows, where it squeezes between the mill pond and railway viaduct.

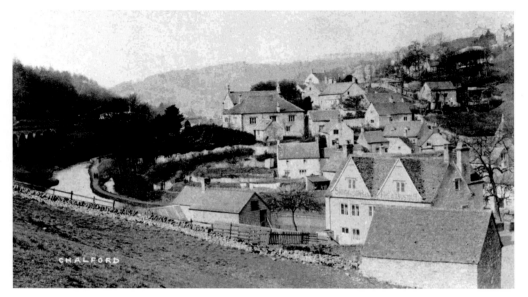

BELOW VALLEY LOCK, *c.* 1910. After passing the narrows the canal and River Frome ran together towards Valley Corner, where the canal passed under Marley Lane into Valley Lock by the Valley Inn (seen here in the foreground). The inn was owned at this time by Smith and Sons of Brimscombe Brewery (see page 41). The large house in the centre is Green Court, an old clothier's house with historical connections with Sevilles Mill. An ancient name for this area of Chalford is Stephensbridge.

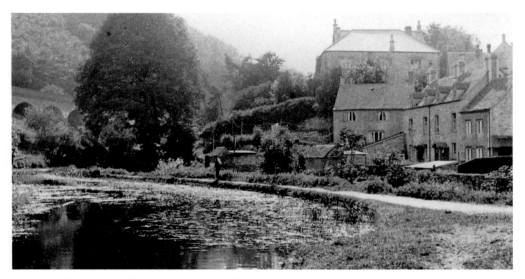

BELOW VALLEY LOCK, *c.* 1920. By the Valley Inn the canal widened appreciably, there being a small wharf here for an adjacent coal merchant. It was probably a convenient mooring-place for barges. The crews could refresh themselves at the Valley Inn or at the Boat Inn (behind the cottages on the right).

BELOW VALLEY BRIDGE (*c.* 1905), looking towards Valley Inn and Valley Lock. Tylers Mill was used for woodworking but was probably a small woollen mill. The Valley Inn was previously known as the Clothiers Arms, and was once a clothier's house. The mill was demolished in 1934 but the stonework of the millrace still bears the marks of a small waterwheel. The River Frome is on the left.

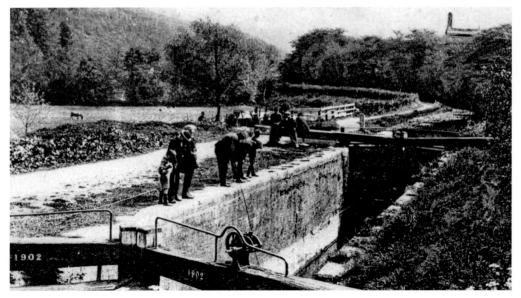

GOLDEN VALLEY LOCK, *c.* 1905. Usually called Valley Lock and seen here from the Marley Lane bridge. Above this lock the canal stays at this level for about half a mile up to Boultings Lock. The building up in the trees with a chimney was Chalford Water Works, in use until 1927 when operations were moved down the valley to Belvedere Mill. These old buildings are now used for the restoration of old cars.

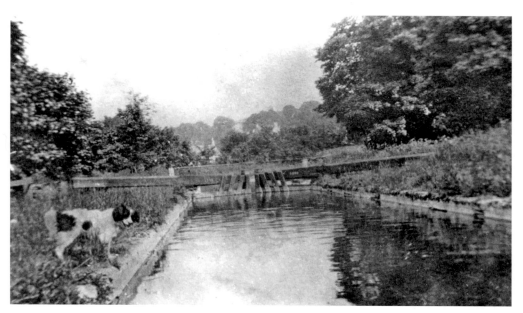

BOULTINGS LOCK (*c.* 1905), looking towards Bakers Mill. Below this lock the canal was sufficiently wide to turn a barge. During the First World War the adjacent woods were felled and loaded onto barges at this point and taken down to Bourne where the trunks were offloaded onto railway wagons at Brimscombe sidings for transport to South Wales.

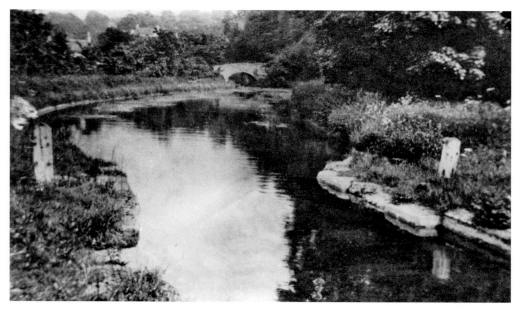

ABOVE BOULTINGS LOCK, *c.* 1910. This section was known as the 'Conk', as it had been concreted by the Canal Trust around 1900. Bakers Mill House is framed in the trees on the left, with the roof of Hattons over the trees.

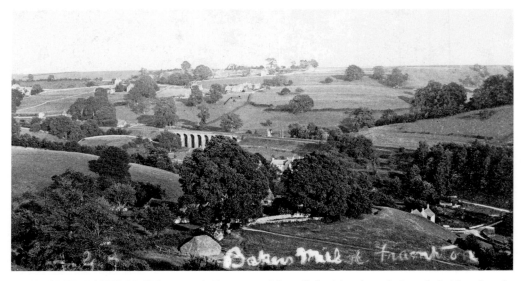

VIEW OVER BAKERS MILL towards Frampton Mansell, looking from below Oakridge church, with Bakers Mill in the bottom right-hand corner and the lock immediately to its right. Bakers Mill House is partly hidden by the grassy bank. In the trees, lower centre, is Frampton Farm with Hattons above it. The railway viaduct is clearly visible and to its right is the roof of Frampton Manor House. Here the railway has a gradient of one in sixty. Today this is still a favourite photographic spot for steam train enthusiasts.

BAKERS MILL LOCK, *c.* 1885: the upper gate beams are on the right. The canal reservoir, built by the Canal Company, stretches east on the left.

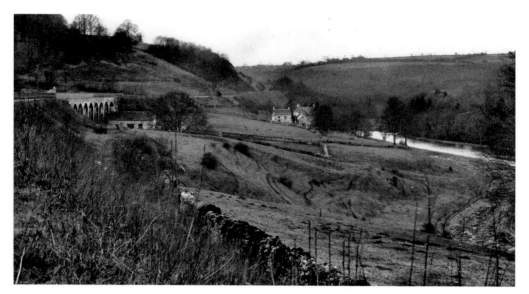

MANOR GROUNDS (*c.* 1938), looking west from Frampton Mansell to Bakers Mill. The reservoir is on the right and Hattons in the centre. Faint above Hattons is the sloping railway bridge known as Wesley, or Jackdaw Bridge. Note the empty canal (bottom right) just before Pucks Mill Lower Lock.

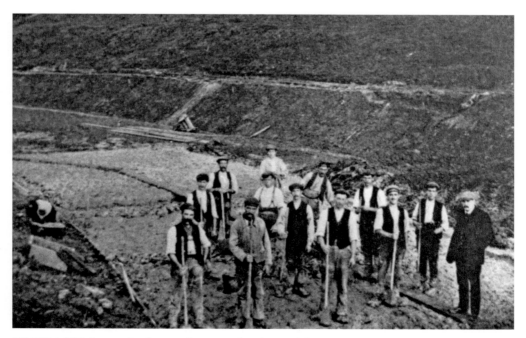

PUCKS MILL Lower Lock pound, 1907. The clay-puddling gang poses for a photograph. Each man has a clay-grafting tool which was used to work the clay, as they trampled it together with their feet.

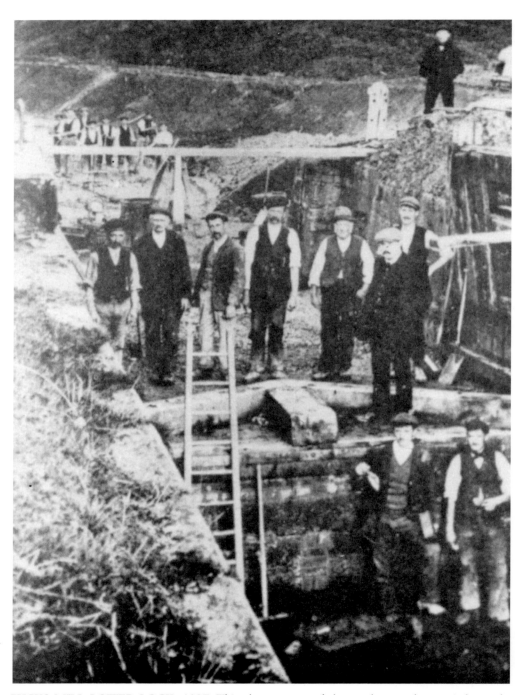

PUCKS MILL LOWER LOCK, 1907. This shows some of the workmen who carried out the restoration of sections of the canal bed at Pucks Mill. The workmen are repuddling the lock chamber as an absolute necessity, as the *Gloucester Journal* reported that the leakage would empty the lock in four hours.

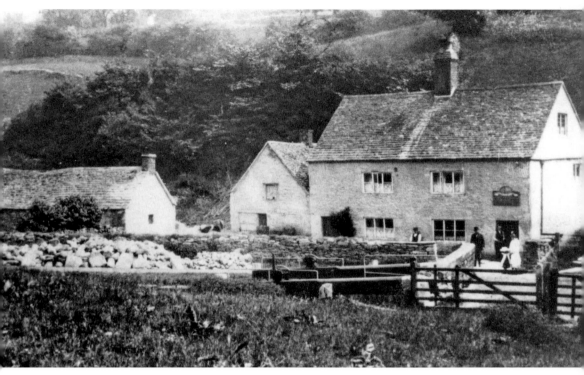

THE OAK INN AT PUCKS MILL, *c*. 1900. The lower gate beam of Pucks Mill Upper Lock is visible and the bridge where the towpath crossed the canal going up. Mr Peart, with his wife and daughter Alice, are near the doorway. The inn was part of Pucks Mill Farm. Perhaps the pile of stone was for repair work on this section of the canal or from the demolition of Pucks Mill itself.

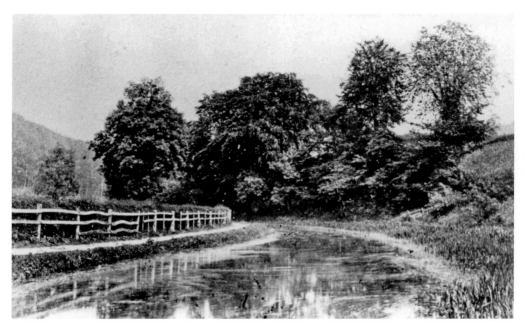

BELOW WHITEHALL BRIDGE (*c.* 1885), looking towards Whitehall Lower Lock, Some distance below the bridge the canal has an almost semi-circular curve before a short reverse curve brings it to the lower lock.

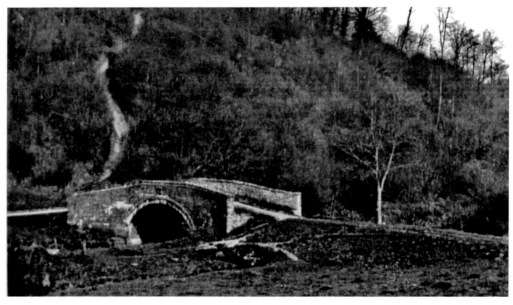

WHITEHALL BRIDGE, 1947. Looking east towards Daneway. The canal has been abandoned for twenty years but the bridge is still in very good condition and is crossed by the track that comes down from the Daneway and Frmapton Mansell on the right and then winds its way up the bank on the left through Siccaridge Woods and back towards the Daneway.

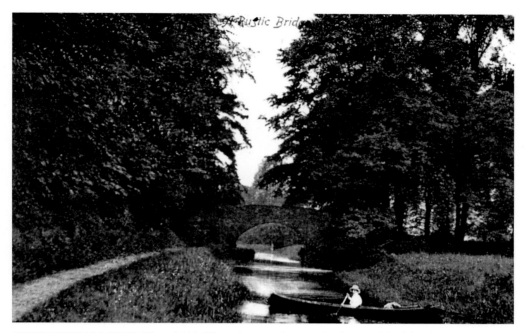

AT WHITEHALL BRIDGE, *c.* 1910. There is enough water in the canal bed for the leisure use of a canoe, but the picture was probably taken in high summer when water would have been low.

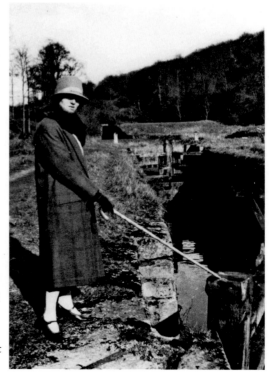

BATHURST MEADOW LOCK, *c.* 1930. Siccaridge Wood Lower Lock is in the distance and there is still some water in the chamber here. Note the bank of the side pond of the Lower Lock. These two locks were numbers two and three of the flight of seven locks from Whitehall Bridge up to the Summit Lock at Daneway.

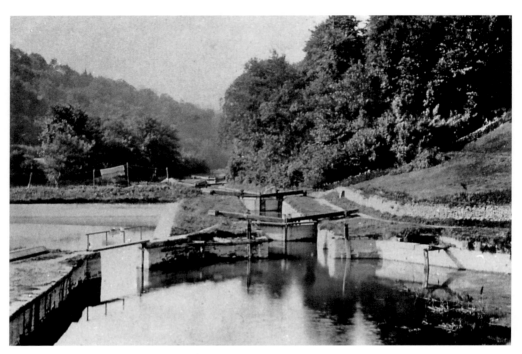

DANEWAY WHARF LOCK, *c.* 1905.

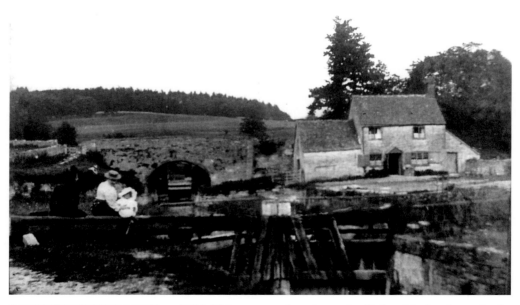

DANEWAY WHARF LOCK, *c.* 1905. This was number six up the flight of locks shown in the top picture. The entrance to the Wharf Basin is to the left in the top picture showing the canal and basin well filled with water. In the lower picture the entrance to the basin is to the right with the Wharf cottage shown clearly at the rear of the wharf down by the side of the bridge.

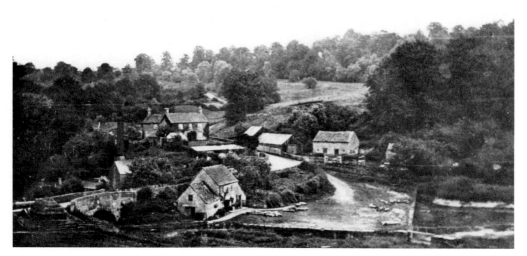

DANEWAY WHARF, 1914.

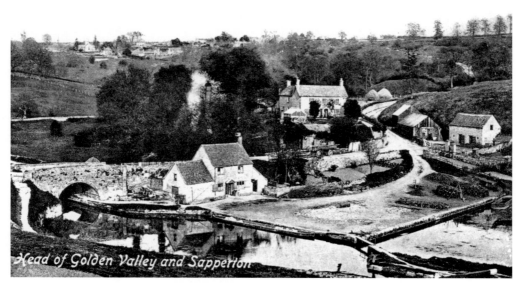

Head of Golden Valley and Sapperton

DANEWAY WHARF, *c.* 1905. The top view is from the Tunley Road across the wharf, with an empty basin. The wharf cottage would have been the home of the Peart family. Mr Peart was carter for the Daneway sawmill, whose buildings are across the road from the cottage. The tall chimney of the sawmill can just be seen. In the lower view Sapperton village is visible on the skyline.

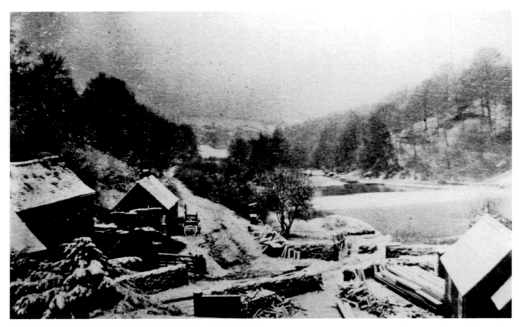

AT DANEWAY (*c.* 1905), looking from the Sawmill house over the wharf basin to Siccaridge Wood in the winter. The track to the left parallels the canal. It crosses it at Whitehall Bridge to go up to Trillies and Far Oakridge.

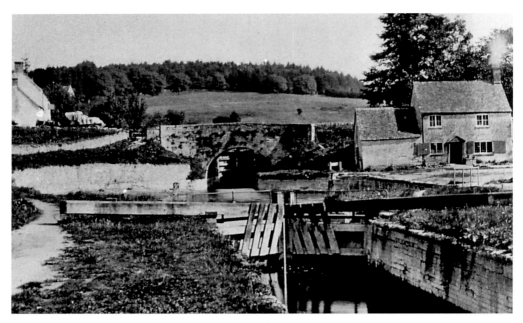

DANEWAY WHARF Lock and Bridge, *c.* 1905. The gates of Summit Lock are shown through Daneway Bridge. The Bricklayers Arms (now the Daneway Inn) is on the left. Note the horse wagon which appears to be carrying sacks of grain or flour.

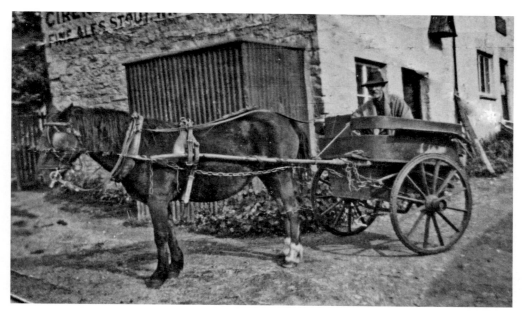

THE BRICKLAYERS ARMS, *c.* 1920. The landlord, Mr Arthur Pearman, is in his milk float, about to start off to deliver milk to Hill House at Tunley. Besides the inn he also had a small farm here, selling his milk locally. He was landlord from around 1910 to 1940. The inn was a Cirencester Brewery House.

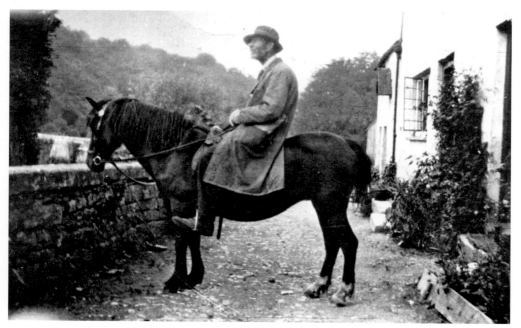

THE BRICKLAYERS ARMS, *c.* 1920. Mr Pearman on his horse.

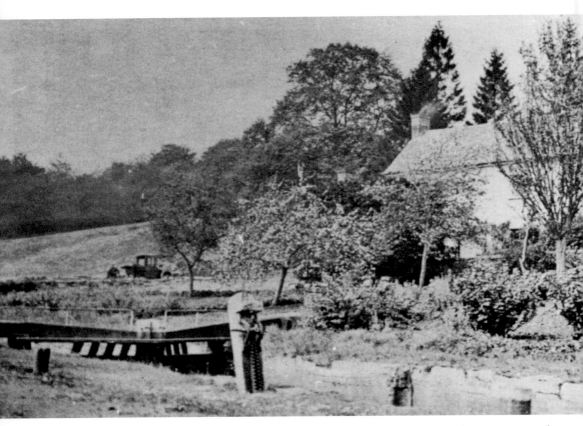

SUMMIT LOCK AT DANEWAY, 1911. Looking across the lock to the Bricklayers Arms on the road. Note the old landau-type car on the road. In the previous picture, Mr Pearman looks out at this scene.

DANEWAY INN, 1967. The garden of the inn has now become the car park and Summit Lock has been infilled. Today it is beneath the cars on the hardstanding. The bed of the canal curves away beyond the car park.

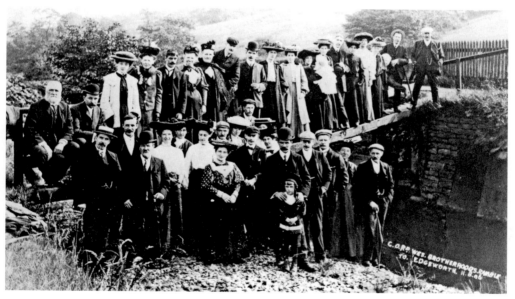

THE CIRENCESTER WESLEYAN BROTHERHOOD, 11 August 1906, on a ramble to Edgeworth (posing at Daneway). It is difficult to identify exactly where the group is posed, but it could be near the wharf or Summit Lock, or even close to the western portal of the canal at Sapperton. However, at this date the party could possibly have come from Cirencester by canal barge. They were just about to start the ramble to Edgeworth, some two miles away.

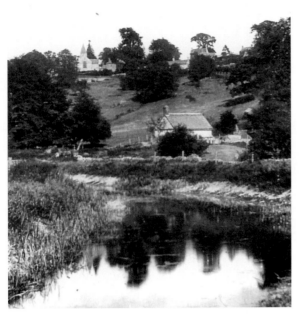

APPROACHING SAPPERTON TUNNEL entrance, *c.* 1912. Just above the summit lock the canal curves to the left, before swinging sharply right to pass the lengthman's cottage to enter Sapperton Tunnel. The battlements and finials of the entrance portal can be seen just to the right of the cottage. At this time the Whiting family would have lived in the cottage which has now completely fallen down. Note Sapperton church on the hill.

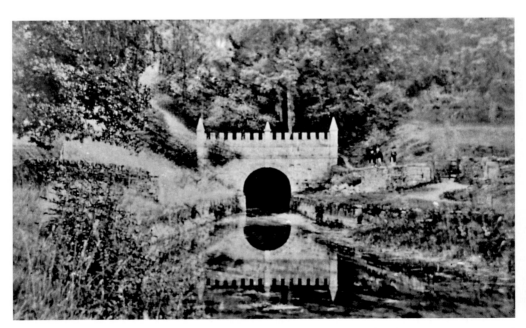

SAPPERTON TUNNEL portal (*c.* 1895), just prior to restoration by the Thames & Severn Canal Trust in the late 1890s. The canal shows lack of maintenance, with about half of its correct depth of water and a bush growing out the stonework.

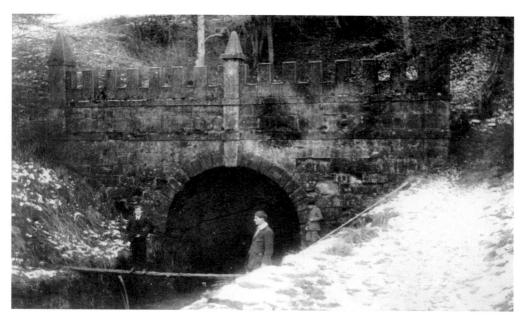

SAPPERTON TUNNEL portal, *c.* 1910.

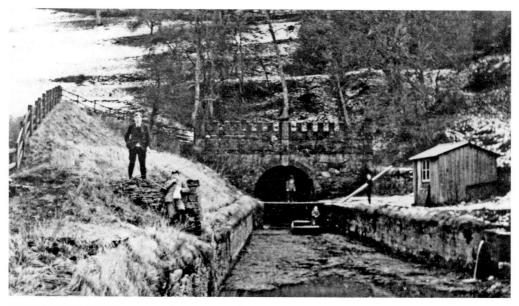

SAPPERTON TUNNEL portal, *c.* 1910. These two pictures were taken by a group of boys from Wycliffe College, who made their way from Stonehouse probably by railcar to Chalford, walking the last four miles to the Daneway. The gothic design shows well, with the snow-covered bank above leading steeply up to Sapperton village. Many people stood on this plank across the entrance to look through the tunnel. There seems to have been very little water in the canal for the time of year.

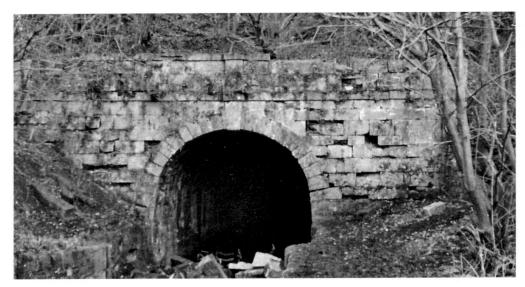

SAPPERTON TUNNEL portal, 1973. This shows the entrance is in a bad state of dereliction, with all of the battlements and finials lying in the canal bed where they have been pushed over. The portal was rebuilt and restored in the 1980s after further vandalism had taken place which reduced the portal down to the bottom string course of stonework above the arch and threatened the whole façade.

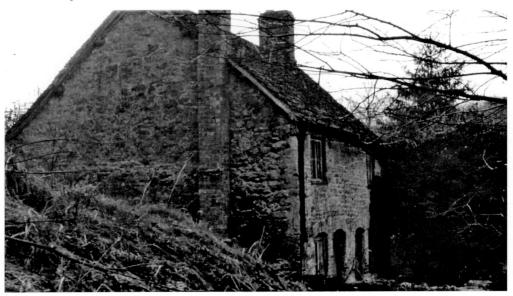

LENGTHSMAN'S COTTAGE by the portal, 1973. This structure was originally built as two cottages, but it was later converted to one lengthsman's cottage around 1905. It was inhabited until the 1960s. Some time after this picture was taken the cottage deteriorated and it has now completely fallen down. The disappearance of this structure at the tunnel entrance will almost certainly be a great loss for the restored canal in the future.

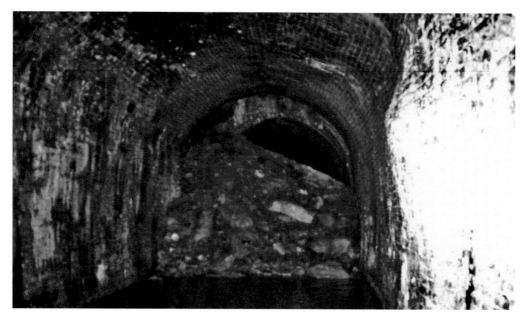

A SMALL FALL INSIDE THE TUNNEL, 1967. Around 130 yd into the tunnel the brick lining has given way and allowed the friable fullers earth to fall through into the tunnel, causing a small blockage.

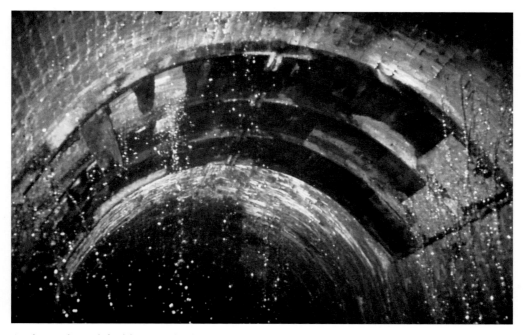

At the geological faultline inside the tunnel, 1967. At about one mile into the tunnel, it passes from inferior oolite back into fullers earth. Large volumes of water passed down the faultline into the tunnel, and elm planking was fitted to the roof here to deflect the water off the barges etc.

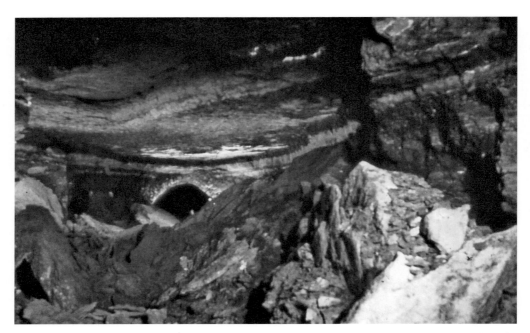

A LARGE FALL IN THE FULLERS EARTH, 1967. Just over halfway through the tunnel in the fullers earth a part of the brick-lined section has collapsed and opened up a large cavern. Note the continuing tunnel arch in the centre.

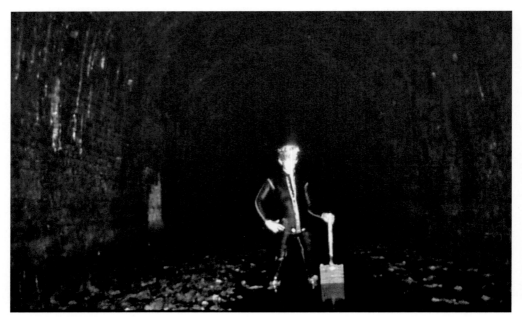

THE LONG ARCHING, 1967. An almost perfect length of the brick-lined section through the fullers earth in the middle of the tunnel. This lined section stretched for nearly two-thirds of a mile, linking the two unlined sections cut through the oolite rock.

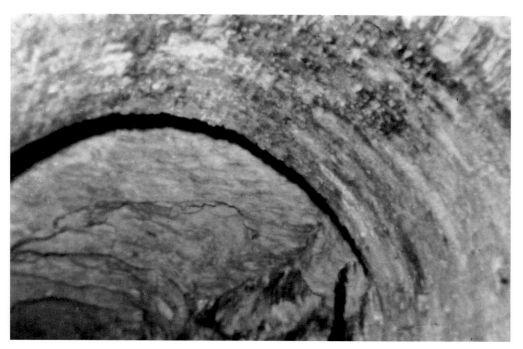

A CHANGE FROM brick lining to natural limestone, 1964.

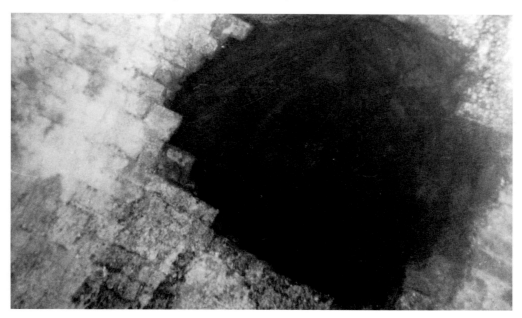

A TUNNEL AIRSHAFT, 1964. These two rather obscure pictures show construction features inside the tunnel. A change from brick lining to natural limestone can be seen (top), while an airshaft is visible in the roof leading up to the surface (below). These shafts were used to haul up the spoil from the excavations during construction.

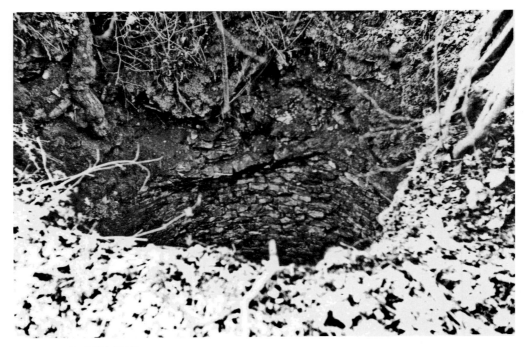

TUNNEL SHAFT, 1977.

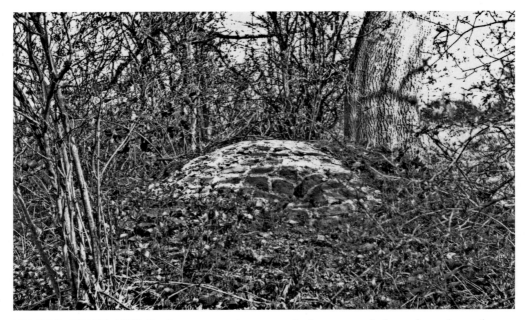

TUNNEL SHAFT, 1977. During construction many shafts were sunk down from the surface to the line of the tunnel in order to get rid of the spoil, and also for access. Some of these remain today as shown in (top) the open shaft in Hailey Woods and (below) a capped-off shaft at Tumbledown, alongside the Cirencester to Stroud Road.

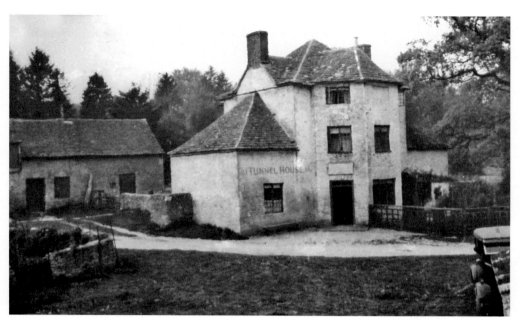

TUNNEL HOUSE, c. 1930.

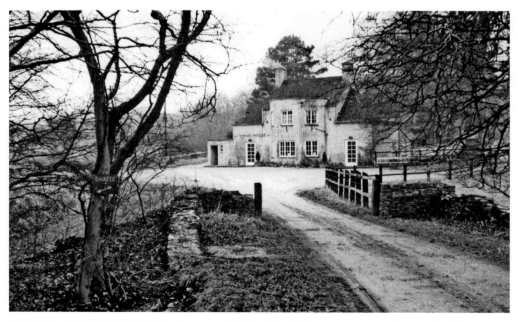

TUNNEL HOUSE, 1962. This inn was built by Lord Bathurst exclusively as a lodging-house for men working on the construction of the tunnel. It is situated almost over the tunnel portal at Coates, and was originally known as the New Inn. It is shown (top) in its original style, with a large stable block to the rear. The building was reconstructed (below) after it was almost destroyed by fire in 1952. It is now without its top floor and good proportions.

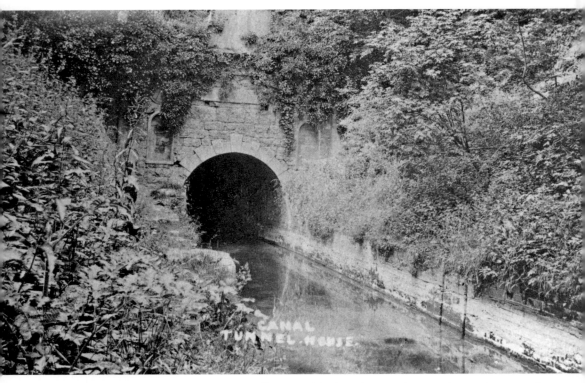

COATES TUNNEL PORTAL, *c.* 1905. This portal is deep in a cutting, as the canal approaches the steeper ground here. It was of a classical design, with niches, columns and entablature, and is perhaps more impressive than the Gothic design of Sapperton portal. The niches did not contain statuary and the tablet was uncarved. Ivy has almost overgrown the structure and has hidden the two columns, one at each side. Note the double stop-plank grooves on the right, between which there was a drain with an iron lid down into a lizen hole in the oolite rock below. Dependent upon the positioning of these stop-planks, either section could then be drained of water for maintenance purposes. Strictly enforced company rules regulated the passage of vessels through the tunnel, allowing four hours' navigation alternately each way throughout a twenty-four hour period.

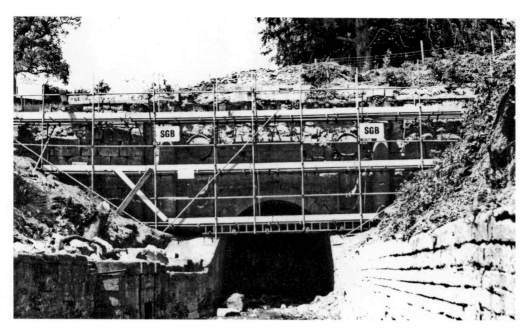

RESTORATION WORK at Coates portal, July 1976.

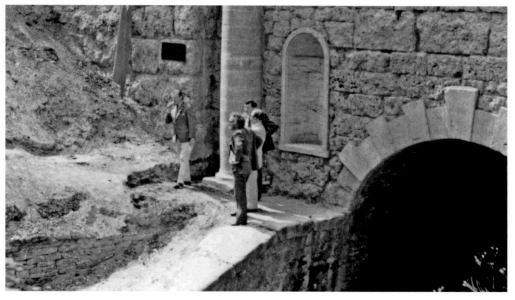

REOPENING CEREMONY at Coates portal, 23 July 1977. The Trust undertook large-scale major repairs to the tunnel façade. The rebuilding required the replacement of a good deal of the stonework and was carried out during the drought of 1976. One year later an official ceremony took place, at which Lord Bathurst unveiled a bronze plaque which was fitted to the façade. In the lower view Lord Bathurst is seen making a speech following the ceremony. The whole event was rounded off with a celebration fête in front of Tunnel House.

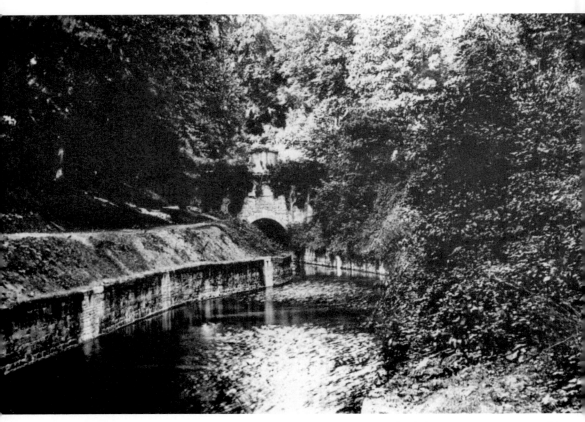

THE KING'S REACH, *c.* 1905. The barge lay-by is shown on the left, just at Coates Tunnel entrance. Barges would have had to wait here for their turn to navigate the tunnel. Note the tunnel portal just round the corner and also the low water level, typical of high summer on the summit level.

THE KING'S REACH, *c.* 1905. The long length of canal approaching Coates portal was built in a deep cutting down into the oolite rock. This rock is full of faults and cracks into which the water drained away in dry conditions, and up which water came in wet conditions. To solve the problem Gloucestershire County Council concreted the whole length in the early 1900s and today it still remains in good condition. Note the heavily wooded sides of the cutting.

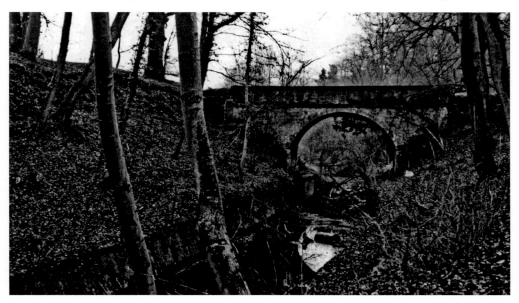

TARLTON BRIDGE, 1962. This beautifully proportioned bridge was built across the end of the King's Reach for the small road from Coates to Tarlton. The mature tree growth was felled as part of Bathurst Estate woodland management programme in the early 1970s. A general programme of clearing-out and towpath reinstatement followed along this whole length.

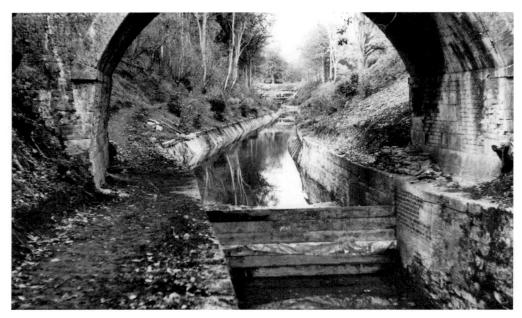

RESTORED KING'S REACH, 1976. In October 1976 stop planks, installed in the grooves below Tarlton Bridge, successfully held back 2 ft 6 in of water that had flowed out of the tunnel.

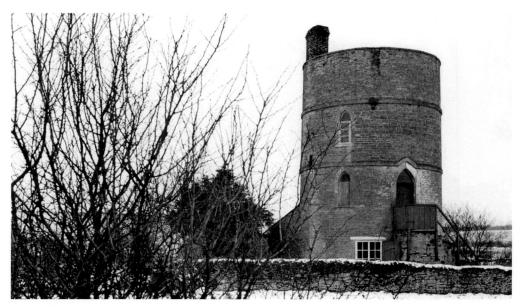

COATES ROUNDHOUSE, *c.* 1950. The second of five roundhouses built as lengthsmen's cottages along the canal, this roundhouse was possibly based on an earlier design to be seen in Lord Bathurst's Park at Cirencester. The ground floor was for storage, with the second and third floors as living accommodation, hence the outside stone steps up to the door. The roundhouse was probably still inhabited at this date.

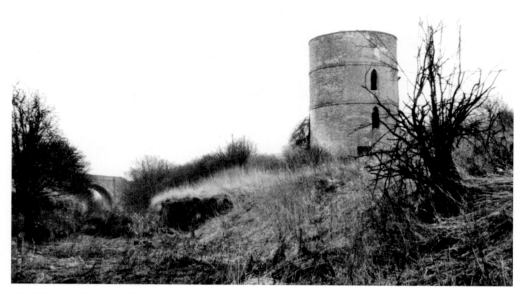

COATES ROUNDHOUSE, 1962.

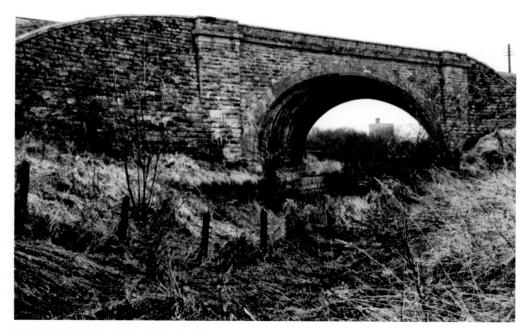

SKEW RAILWAY BRIDGE, 1962. Two very overgrown views at this isolated spot, showing (top) the roundhouse. It could only be reached along the towpath, and stood next to a masonry waist for stop planks. The high GWR bridge across the canal (below) was built in 1844. Note the fence across the canal, marking newly established boundaries set up after the abandonment and sale of the land in 1927.

THAMES HEAD, 1902.

THAMES HEAD, 1902. Two views of the spring at Thames Head, the source of the infant River Thames, flooded in winter and dry in summer. It was a favourite location for Edwardian outings and photographs. The canal was built up on the slope behind the spring, and the stone boundary wall can be seen in the top view.

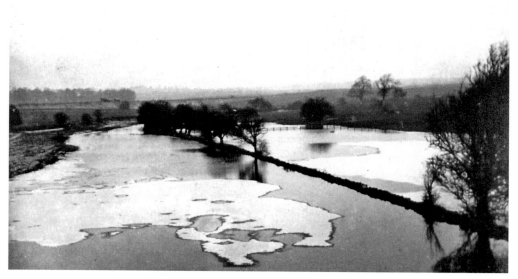

THE FLOODED UPPER THAMES valley at Trewsbury, *c.* 1900. Serious winter flooding has taken place in the upper reaches of the valley by Thames Head. The canal was purposely built on the slope to the right to avoid this problem. Note the railway line embankment to the left.

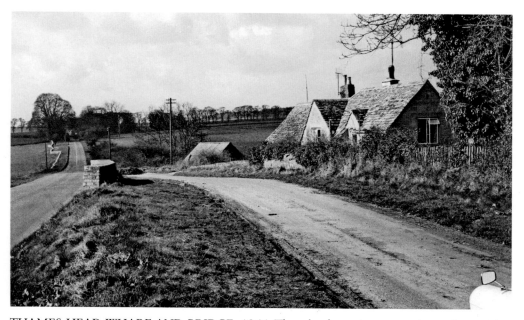

THAMES HEAD WHARF AND BRIDGE, 1966. The wharf was important due to its position alongside the Fosse Way road to Tetbury and district. An agent was initially located here. There was a small warehouse, stables and an agent's house, which can be seen to the right. Note the 1962 realignment of the road over to the left of the bridge.

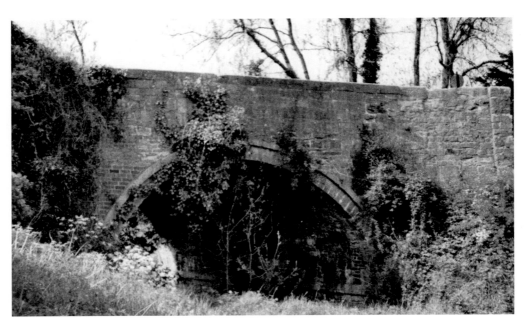

THAMES HEAD BRIDGE, 1950.

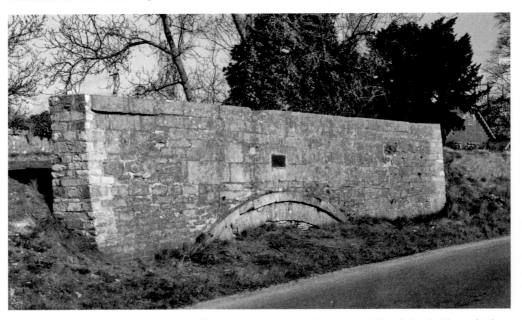

THAMES HEAD BRIDGE, 1966. The top view shows the south side of the bridge which is carrying the Fosse Way main road from Cirencester to Tetbury over the canal, and the stone-edged wharf is just through the arch beyond the bridge. In 1962 the road was realigned off this original bridge and placed just to the south and therefore the parapets and arch were carefully preserved. The lower view is taken from the realigned road again looking at the south aspect of the original bridge where a small plaque thoughtfully records the details.

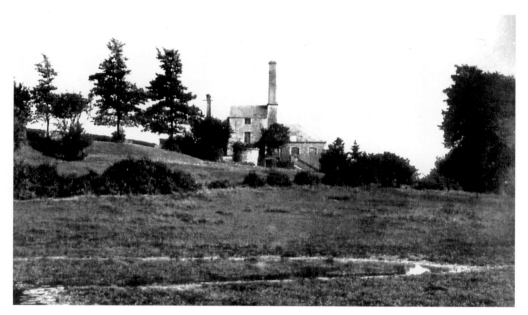

THAMES HEAD pumping station, *c.* 1905.

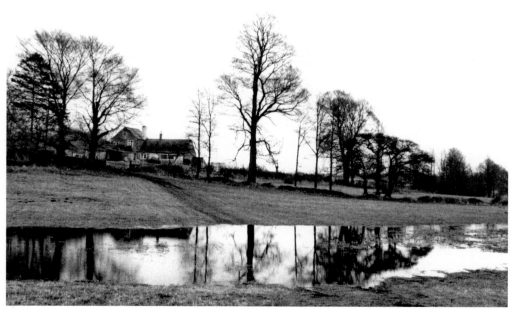

THAMES HEAD pumping station site, 1962. Taken from the Fosse Way, the top photograph shows the complete pumping station with the Cornish engine that was erected here in 1854 and pumped water until 1912. The canal is high up on the bank at the top left. The lower view was taken long after the engine, its house and boiler were scrapped in 1941 leaving only the two cottages built for the two enginemen to live in. Note the infant River Thames in the top view, and still more floods in the lower scene.

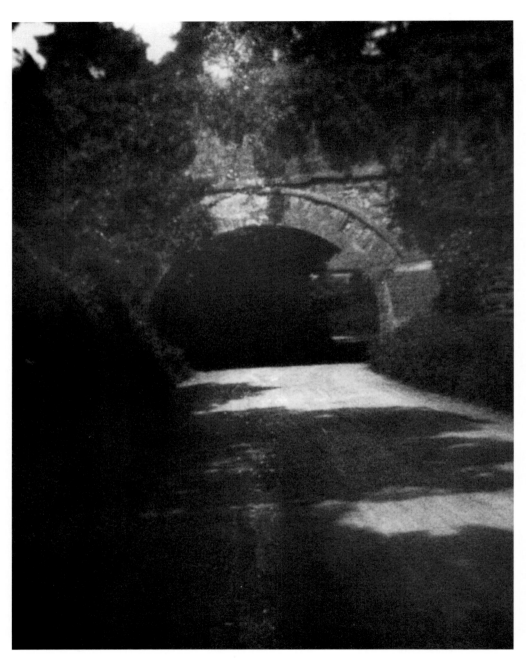

SMERRILL AQUEDUCT, 1922. The summit level of the canal needed a long embankment and an aqueduct to negotiate the shallow valley just south of Smerrill Farm. The large arch of the aqueduct across the Cirencester to Kemble road is seen from the Kemble side. The arch and one side of the embankment were removed in 1960 in a road-straightening scheme to get rid of the awkward angle and height restriction to the increasing road traffic. Any restoration of this break in the canal in the future will be a difficult and costly exercise.

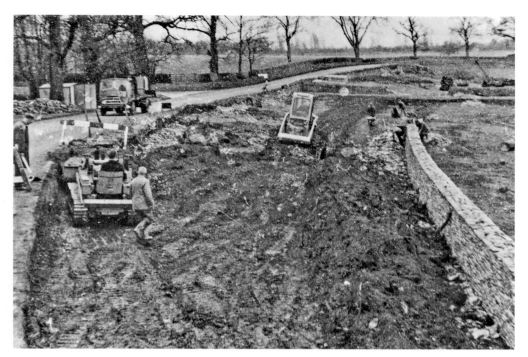

SMERRILL, 1960.

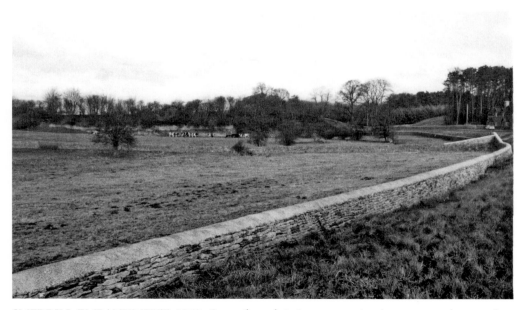

SMERRILL EMBANKMENT, 1962. Council work is in progress (top) to remove the aqueduct and realign the road. After completion (below) the embankment can be seen through the trees on the skyline.

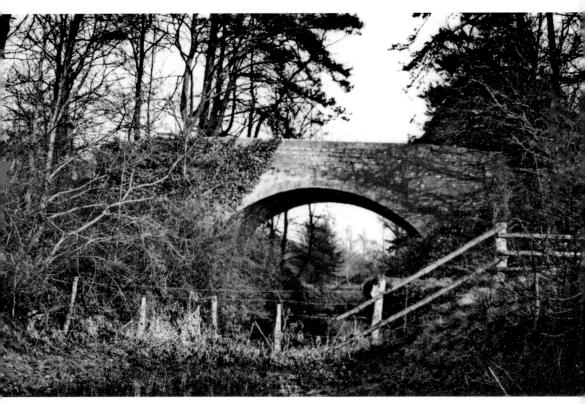

PARK LEAZE BRIDGE, 1938. This was an isolated bridge which carried a small track from Kemble through to the Fosse Way and served only a few farm buildings. The fence in the foreground denotes changes of land ownership after abandonment of the canal in 1927. The bridge has long since been demolished.

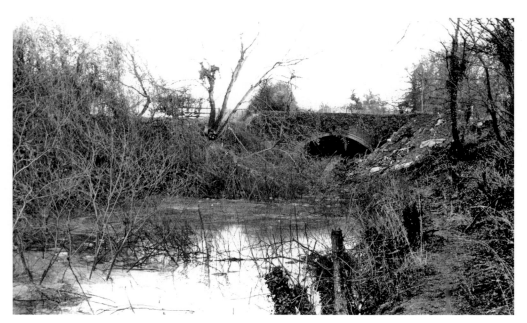

LEVEL BRIDGE, 1963.

CANAL AT FURZEN LEAZE, 1963. One of the few stretches of summit level to hold water after abandonment was the length by Furzen Leaze. The Level Bridge (top) is about to disappear under tipped rubble, while the canal bed (below) is holding water alongside the road from Siddington to Ewen. The canal bed was used as a council rubbish tip all the way from Minety Road Bridge up to this wire.

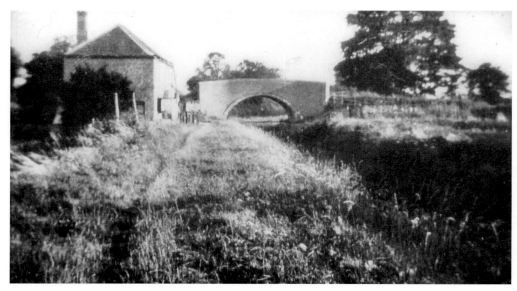

BLUEHOUSE, 1923.

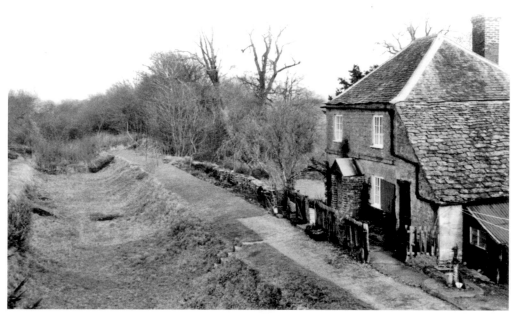

BLUEHOUSE, 1962. At Bluehouse Bridge a lengthsman's cottage was built to a rectangular plan with a hipped roof. These cottages were a complete contrast to the design of roundhouse lengthsmen's cottages. Storage was underground in the basement, and living accommodation was reached off the towpath. The canal is empty of water along this notoriously leaky section (top), but is seen four years before its official abandonment. The view below, taken from the bridge, clearly shows the canal profile of the summit level.

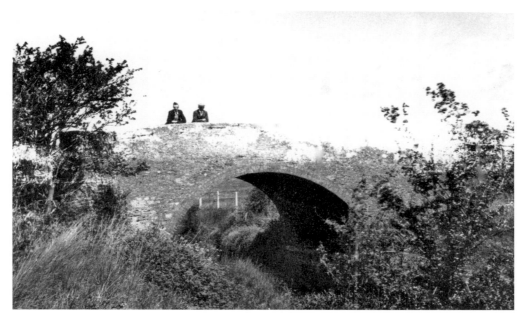

EWEN BRIDGE, 1922.

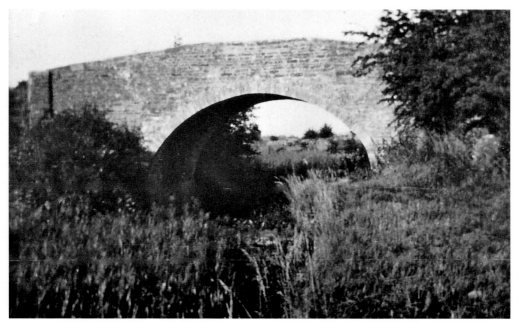

MINETY ROAD BRIDGE, 1922. The canal follows the 365-ft contour along the summit level and in the vicinity of these two bridges it is forced to make a series of sharp turns along that contour. Minety Road Bridge was also known as Somerford Road Bridge. Both bridges have long been demolished.

SIDDINGTON JUNCTION, 1913.

SIDDINGTON JUNCTION, 1963. Two photographs taken fifty years apart, showing the junction at Siddington with the Cirencester branch line. There is a good water depth (top), with the branch line going off right. Siddington Top Lock is behind the camera, down off the summit level. Siddington was always an important place, and an agent and clerk of the works for the eastern end of the canal was stationed here, alongside the canal. His job was to keep the headquarters at Brimscombe informed of the state of trade, and of the water supply coming down the Cirencester branch line from the River Churn for the summit level pound. The derelict and empty canal bed is seen (below) as it was nearly fifty years ago, with Barton Farm and Siddington Lodge in the background.

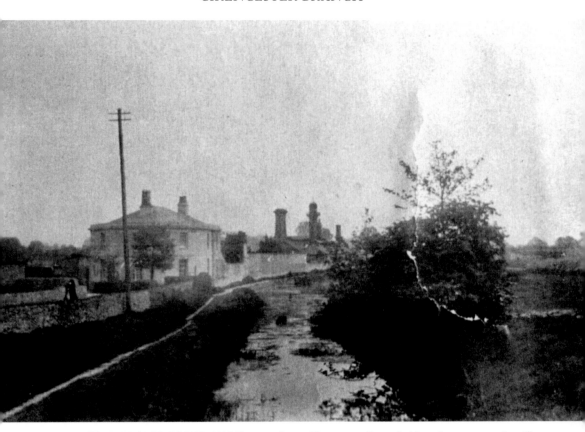

CIRENCESTER BRANCH LINE (1923), seen from Chesterton Lane Bridge. Some water is still flowing along the branch line from the feeder which entered the canal at the head of Cirencester Wharf. Although the canal has not yet officially been abandoned, it is by no means navigable. The feeder was eventually blocked off in 1929, causing bad floods in the town. Note the stone-edged wharf alongside Gas House, where coal was unloaded down into the gasworks yard, and also the chimneys and retorts of the works in the centre. The towpath looks fairly well used and was probably a short cut between the town and Siddington.

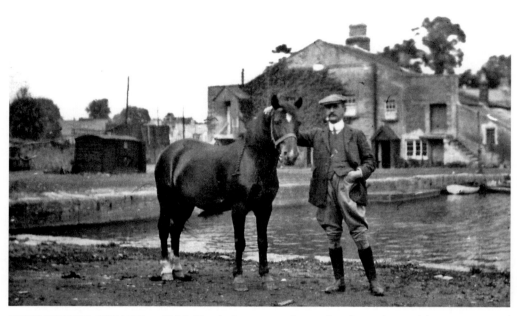

CIRENCESTER WHARF, *c.* 1915. Frank Gegg owned a coal, coke and gravel business centred on the canal wharf at Cirencester, and this picture shows him with his horse Joey on the wharfside at the terminal basin. Note the combined agents' house and warehouse behind them and the weighbridge shed and wharf entrance to the left of the horse. Underneath the horse's belly is the feeder culvert into the canal from the River Churn at Barton Mill.

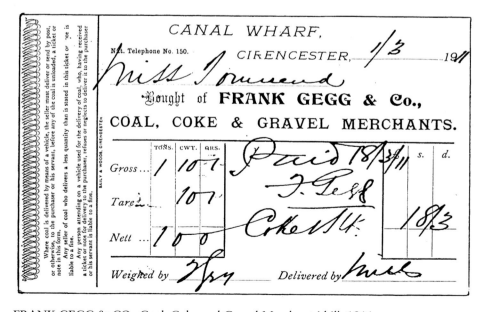

FRANK GEGG & CO., Coal, Coke and Gravel Merchants' bill, 1911.

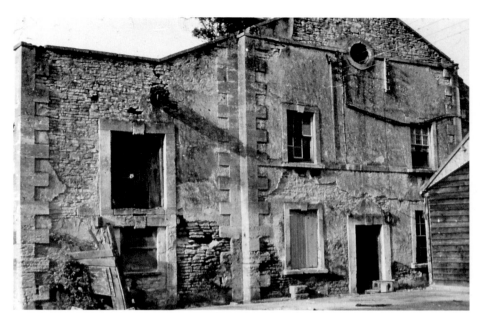

CIRENCESTER AGENT'S house and warehouse, 1975.

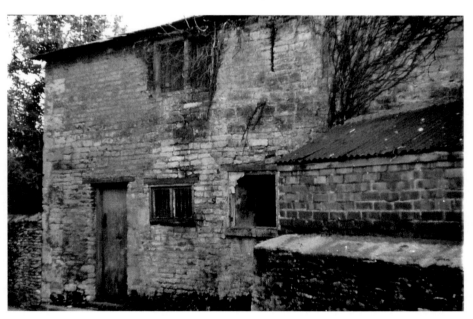

THE REAR OF CIRENCESTER WAREHOUSE, 1975. Two pictures taken four months prior to demolition in September 1975. The agent lived in the central portion and the warehouse formed the two sides and rear of the house. It was of rough stone, plastered with stucco and ashlar quoins. Since abandonment it had been used as a dwelling and for storage. It was gradually neglected, and had deteriorated until it became unsafe. Two similar buildings at Cricklade and Kempsford have survived quite satisfactorily.

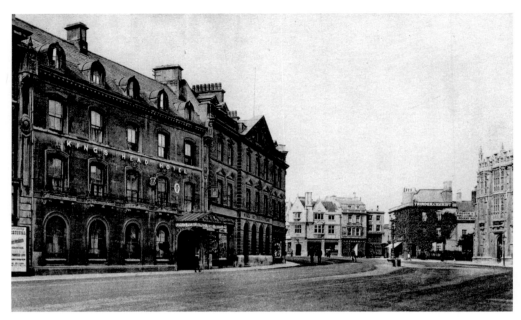

KING'S HEAD HOTEL, Cirencester, *c.* 1910.

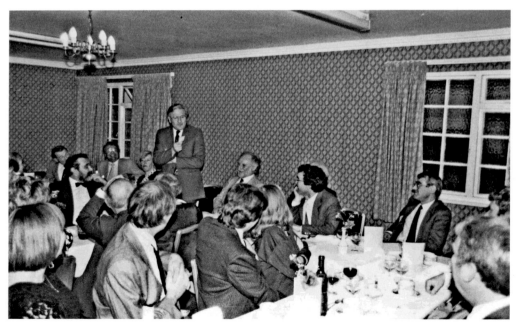

BICENTENARY DINNER at the King's Head Hotel, 17 November 1989. The hotel was used by the Thames & Severn Canal Co.'s proprietors for their inaugural meeting to open subscriptions for the canal in 1783. It eventually opened six years later. The lower picture is of the bicentenary celebration dinner of the opening of the canal. Mr Bruce Hall, Chairman of the Stroudwater, Thames & Severn Canal Trust, is giving a speech.

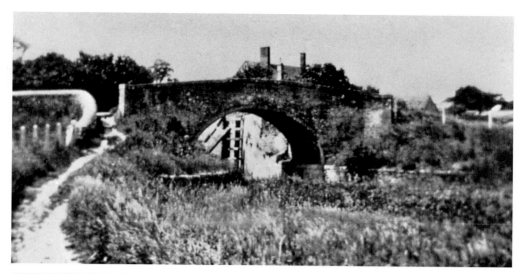

OVERTOWN BRIDGE at Upper Siddington, 1922. The broken lock gates of Siddington Upper Lock, down off the summit level, can be seen through the arch of the bridge. Over the parapet can be seen the roof and chimneys of the clerk of work's house alongside the junction above the lock. Altogether a derelict scene, some ten years after navigation ceased.

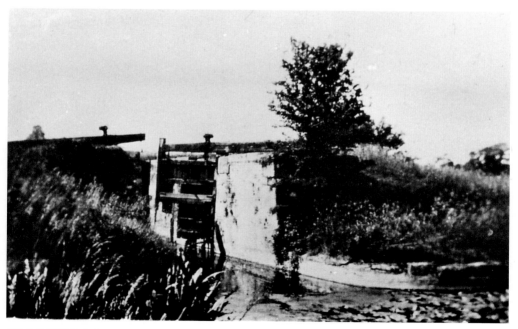

SIDDINGTON THIRD LOCK, 1922. This was the third lock of the flight of four locks at Siddington. A great deal of tree and scrub clearance has been carried out along these locks, which all had a deep drop of 9 ft 9 in.

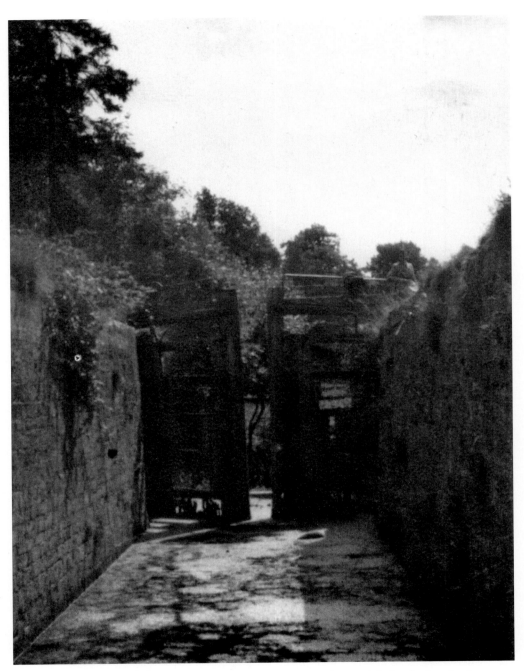

SIDDINGTON LOWEST LOCK, 1926. Also known as the Fourth Lock, its site has now completely disappeared under a house called Greenways. Alongside the house, the towpath still exists today as an alleyway. Immediately below the lock was Greyhound Bridge, carrying the Siddington to Ashton Keynes road. Once again this site represents a major obstacle to any restoration of the canal line.

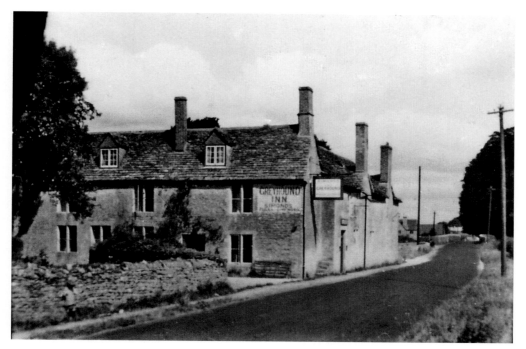

THE GREYHOUND INN at Siddington, *c.* 1950. At the slight rise in the road just beyond the Greyhound Inn can be seen the parapets of Greyhound Bridge. The deep Siddington Lowest Lock which was the fourth lock of the flight down off the summit level is just off to the left of this bridge.

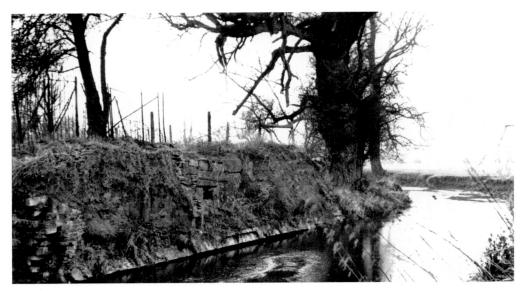

RIVER CHURN aqueduct, 1962. Between Siddington and South Cerney the canal was carried across the River Churn on a low aqueduct, under which the river flowed partly in a siphon. It continually blocked, causing flooding on Plummers Farm, and it was eventually removed with explosives by the Thames Conservancy. In this picture all that remains are buttresses and lower parts of the arching on one side, with iron railings across the canal bed on the left.

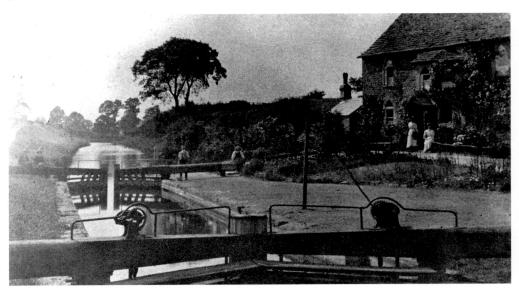

SOUTH CERNEY Upper Lock and Wharf, c. 1910. This was the top lock of a flight of three. Mr Tuck, the resident of the cottage, combined the three jobs of lock-keeper, wharfinger and lengthsman, and is seen here standing next to the top right-hand balance beam, with the rest of his family nearby. Trade was typical of this very rural location and was mainly in stone, bricks, corn and coal.

THE CANAL, SOUTH CERNEY. 313.

SOUTH CERNEY Middle and Lowest Locks *c.* 1910. A very rare view across the fields from the bridge at the upper lock, showing the large circular pounds between these fairly deep locks. All three had a 9 ft 4 in fall and continued the rapid descent from the summit level started by the four locks at Siddington. The site has now almost disappeared under farmland, but the lock chambers are probably buried underground and should therefore remain in good shape for future restoration.

APPROACHING CRANE BRIDGE, 1904. The canal is very isolated here and crosses farmland down to Cerney Wick. The bridge was also known as Minute Lane Bridge.

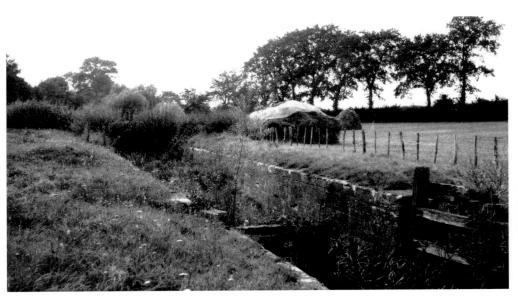

BOXWELL SPRING LOCK, 1962. Also known as Shallow or Little Lock, this 3 ft 6 in fall lock was built in 1792, following the realization by the Canal Company that canal levels and usable water supplies did not align themselves here. The insertion of this lock, which was beautifully built of faced stone, meant that water from some of the springs just below it could be channelled into the canal to help supply the two deep locks at Humpback and Wildmoorway, further down. The lock is seen here in a poor state.

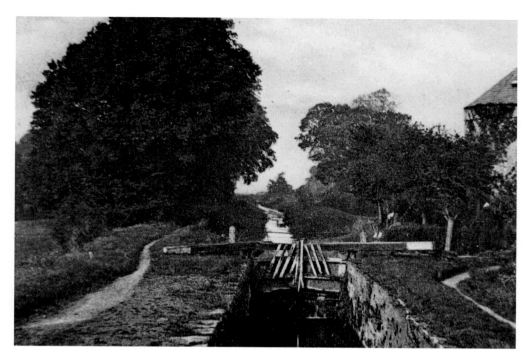

CERNEY WICK LOCK, 1915.

CERNEY WICK ROUNDHOUSE, 1946. The top view shows the lock a few years after navigation ceased, and already the left-hand balance beam is broken. The roundhouse which is the third one along the canal still appears to be lived in. A small amount of trade was carried on from here, using the lock as the wharf. The lower view shows the derelict roundhouse just prior to restoration after the last war. The lock chamber was rebuilt and fitted with new top gates in the 1980s and is still in good condition and possibly stands in readiness for future use in the years to come.

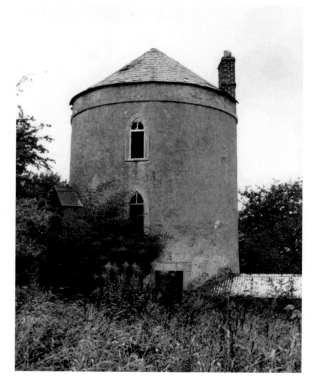

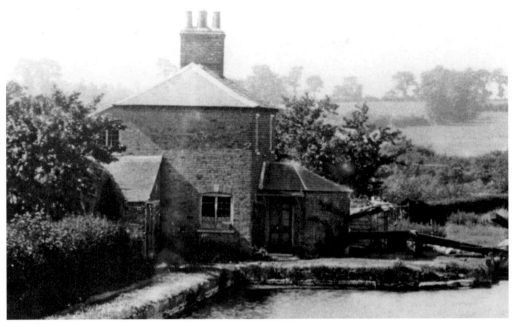

TOLL HOUSE at Latton Junction Basin, *c*. 1895.

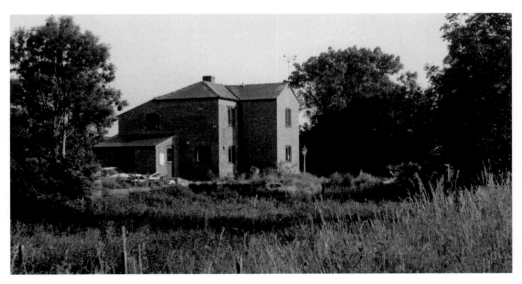

REBUILT AND EXTENDED TOLL HOUSE at Latton Basin, 1988. The toll house in the top view was actually North Wilts. Canal property and was built in 1819 for their agent to collect tolls from traffic leaving the Thames & Severn and going on to the North Wilts. Canal. The large basin, the corner of which can be seen in the foreground, was Thames & Severn property. It was probably used as a transhipment wharf, as the North Wilts. Canal was narrow compared to the Thames & Severn. In the lower view the original toll house has been extensively rebuilt and extended.

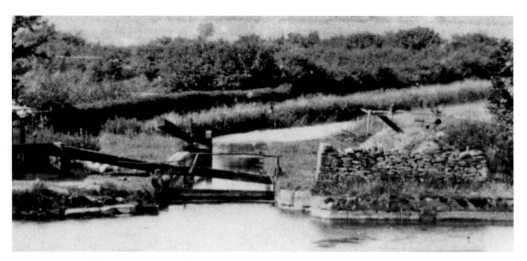

LATTON JUNCTION STOP LOCK, *c.* 1895. The North Wilts. Canal can be seen curving away in the background, but in effect the lock was two separate stop gates with the nearer one belonging to the Thames & Severn and the far one to the North Wilts. The intention was that either company had control over loosing water to the other company, should their level be higher.

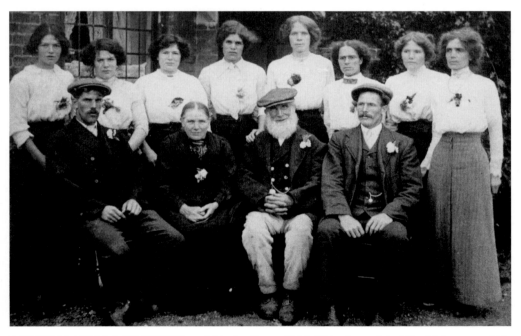

LATTON BASIN LOCK-KEEPER and his family, *c.* 1915. This shows Mr Alfred Howse and his wife Prudence with their children. Mr Howse was lock-keeper at the basin and lived in the toll house. He had a small market garden adjacent to the toll house and took his produce to Cricklade market either by boat or by donkey cart. Back row, left to right: Bridget, Daisy, Maggie, Nell, Rose, Lily, Prudence, May Ann Polly. Front row: Joe, Mrs Prudence Howse, Mr Alfred Howse, Frank.

THE CRICKLADE ROAD at Latton, *c.* 1905.

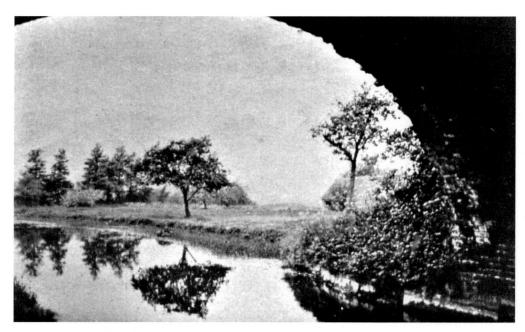

LATTON BRIDGE, 1911. The Ermine Way, the main road from Cirencester to Cricklade, is shown (top) running through the small village of Latton. In the far distance the road crossed the canal and a pony and trap can just be seen approaching the hump-backed bridge. As traffic increased the bridge became a bad restriction, and in 1928 it was one of the first bridges to be demolished following abandonment of the canal in 1927. The view below is from the towpath, looking west underneath the bridge arc.

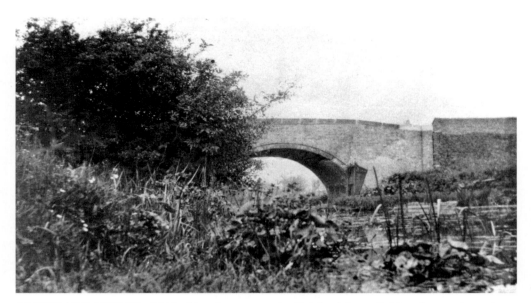

CRICKLADE BRIDGE, 1911. Also known as the Fairford Lane Bridge, it was just above Cricklade Wharf. Some of the shed roofs can be seen over the wall on the right. The wharf here was fairly important, with a permanent wharfinger and warehouse. It must have been a busy place for all commodities, especially agricultural produce, in the years before the railway arrived.

CRICKLADE WHARF, 1975. The agent's house/warehouse is similar here to that at Cirencester and Kempsford. The house formed the central part, with the warehouse along either side and round the back, all under one enormous Cotswold tiled roof. Note the warehouse loading doors and the small office over to the left, where the entrance pillars to the wharf lead in off the road.

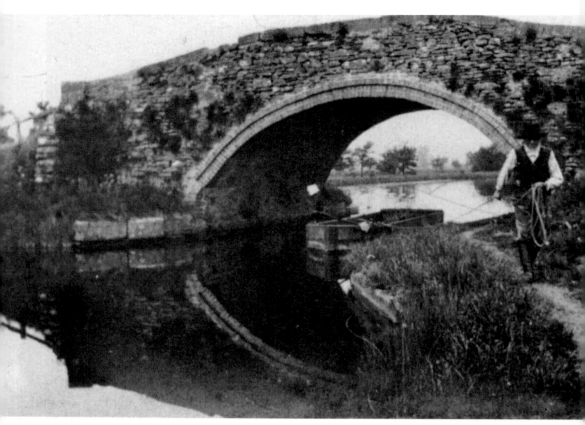

EISEY BRIDGE, 1911. This bridge carried the track into Eisey Farm and also gave access to the land cut off between the canal and the River Thames. 'Old Willum', one of the last lengthsmen to work on the canal, is shown towing his maintenance boat along this isolated stretch.

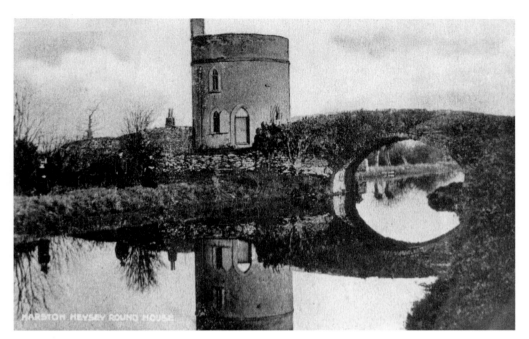

MARSTON MEYSEY BRIDGE, Roundhouse and Wharf, *c*. 1910.

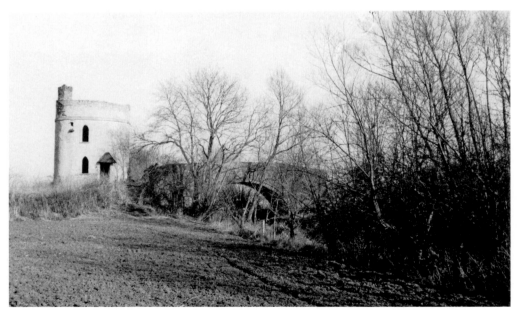

MARSTON MEYSEY (1962), one of the small wharves which only served a village community. The lengthsman/wharfinger was eventually moved to a more useful location when trade declined. The wharf was just through the bridge on the left. In the lower view the roundhouse is derelict, but was later saved from collapse by a coating of cement and the removal of all internal timbers. It has now been carefully restored and is included in a development at the site.

OATLANDS BRIDGE, 1966. Between Marston Meysey and Kempsford there were three brick-built bridges. Both Crooked Bridge and Blackgore Bridge have been demolished, but Oatlands Bridge still stands isolated in the fields which have all been returned to farmland.

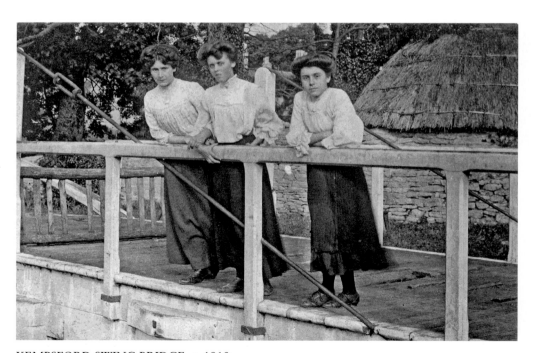

KEMPSFORD SWING BRIDGE, *c.* 1910.

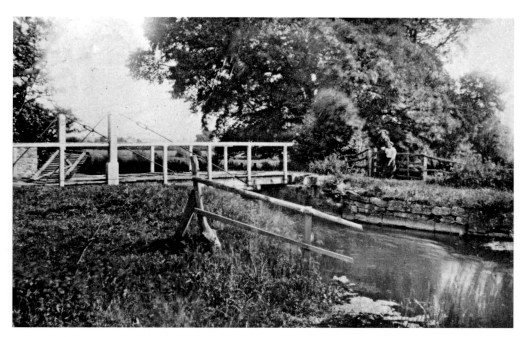

KEMPSFORD SWING BRIDGE, *c.* 1910.

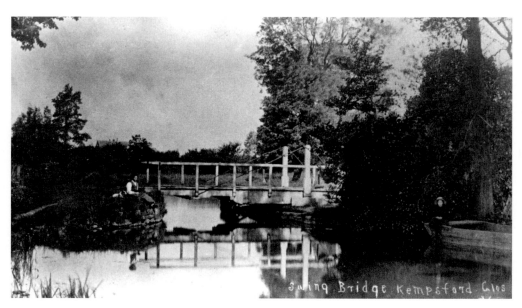

KEMPSFORD SWING BRIDGE, *c.* 1910. The top view is from the west, and the one below from the east. The bridge gave access to fields between the canal and the River Thames that were cut off from the road through the village by the construction of the canal. The bridge was built of wood and tensioned by adjustable steel rods, and was installed in 1899 as a replacement for the previous structure.

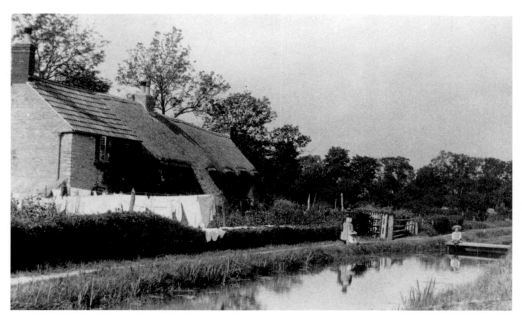

WHELFORD CANAL FEEDER, 1906.

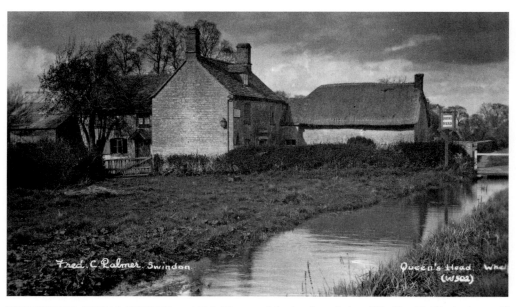

WHELFORD CANAL FEEDER, *c.* 1925. The canal feeder from below Whelford Mill, the last mill on the River Coln, eventually entered the canal at Kempsford Wharf and was needed to supply water for Dudgrove Double Lock and Inglesham Lock, the last three locks on the canal. It is shown here flowing alongside the road between Whelford and Kempsford and past The Queen's Head public house. Note the different types of roofs on the buildings: thatch, clay pantiles, corrugated iron and Cotswold tiles, and the fact that each property had its own little bridge across the feeder.

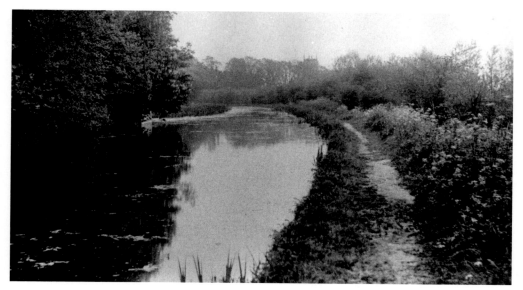

APPROACHING KEMPSFORD WHARF, *c.* 1910. Below Swing Bridge the canal curves gently round towards the wharf. Note the tower of St Mary's church among the trees and, on the left behind the overhanging tree, the boathouse of Kempsford Manor House.

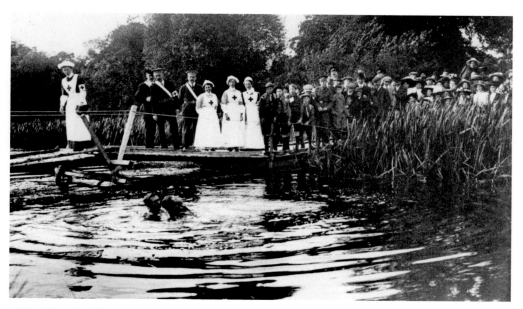

RED CROSS FIELD DAY at Kempsford, August 1912. At about the same location as the previous picture, the Fairford Red Cross Male Detachment and the Fairford Red Cross Nurses carried out field exercises. This involved building a bridge across the canal, rescuing people from the water and cooking meals using a field kitchen. All these activities were keenly watched by a large crowd of people who found it good entertainment.

KEMPSFORD BRIDGE, *c.* 1905.

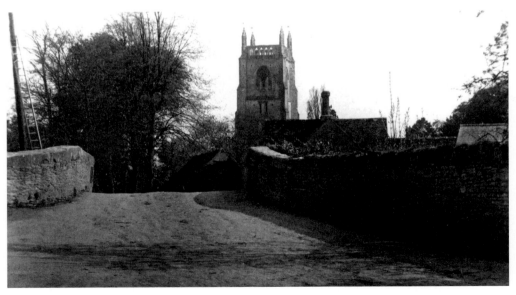

KEMPSFORD BRIDGE, *c.* 1925. There was a hump-backed bridge in the village just past the wharf. In the top view the bridge is shown from the lane down to the church. On the left by the bridge was a small wharf with good access for loading tree trunks straight onto barges. In the lower view the bridge is seen from the village, with St Mary's church in the background. The bridge was soon demolished following the abandonment of the canal.

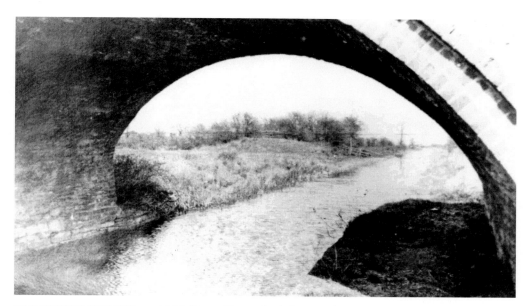

DUDGROVE BRIDGE, *c.* 1915. From Kempsford the canal crosses very isolated countryside devoid of any communities or farms until it approaches Dudgrove Farm. This bridge gave access to the farmland between the canal and the River Thames. The photograph looks down the canal, toward the Double Lock.

AT DUDGROVE, 1911. There are few surviving photographs of the canal along this stretch. This one was taken either above or below Dudgrove Double Lock, looking up the canal.

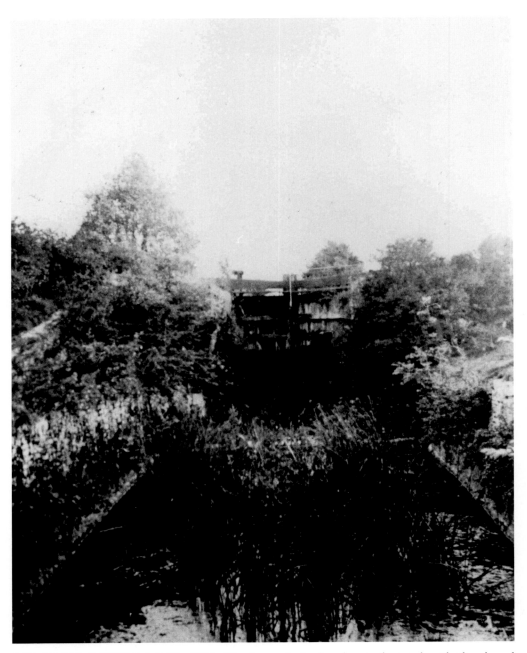

DUDGROVE DOUBLE LOCK, 1923. The lower lock chamber is depicted with the shared middle gates. The upper lock chamber had a fall of 9 ft and lead directly into a lower chamber with a 2 ft 6 in fall. This was wasteful of water, but the lower chamber, which had been quickly but poorly built with drystone walls, enabled the company to continue the line of the canal to Inglesham to join the River Thames. The original intention had been to join the river below the upper lock chamber, but bad navigation conditions in the river made them change their minds.

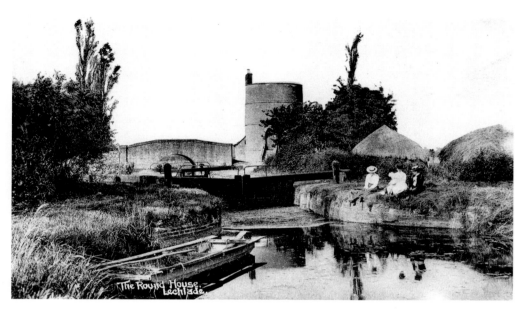

INGLESHAM LOCK, 1906. This was the last lock, which dropped the canal the final 6 ft before it entered the Thames, out through the bridge. The fifth roundhouse was built here for an agent/lengthman and a basin for loading etc. was opened out just above the lock, but the position was bad for trade. It was disused as a wharf by 1813.

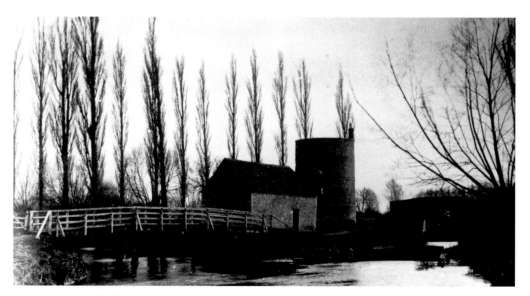

INGLESHAM JUNCTION, c. 1900: the whole panorama at Inglesham. From the right are the lock and bridge, the roundhouse, the small warehouse and the bridge taking the towpath across the River Thames. The canal entered the river here on a sharp corner, just above its confluence with the River Coln, which dramatically increased the flow and depth of water in the river and gave more reliable navigation. Note the Edwardian skiff trip up from Lechlade.

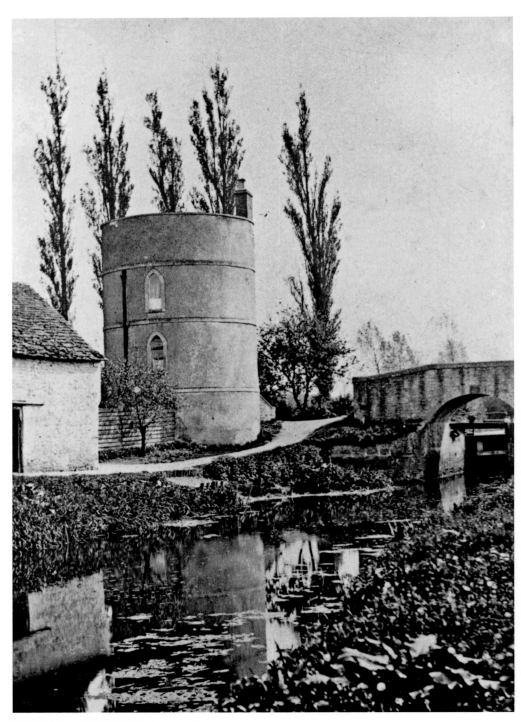

INGLESHAM JUNCTION, *c.* 1910.

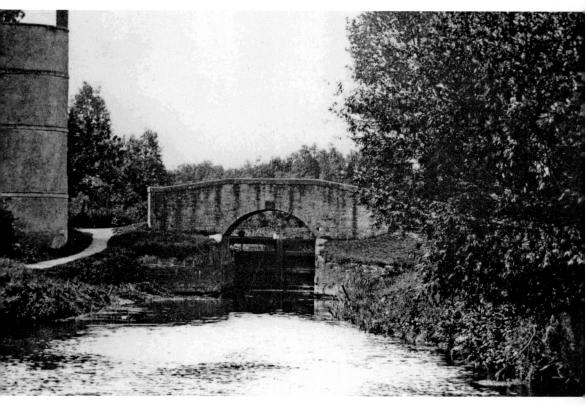

INGLESHAM BRIDGE, *c.* 1905. It was through this bridge on 19 November 1789 that a boat completed the first through navigation of the Thames & Severn Canal, onto the River Thames. Celebrations took place around the district, culminating in dinners at inns in Lechlade followed by a bonfire and a ball.

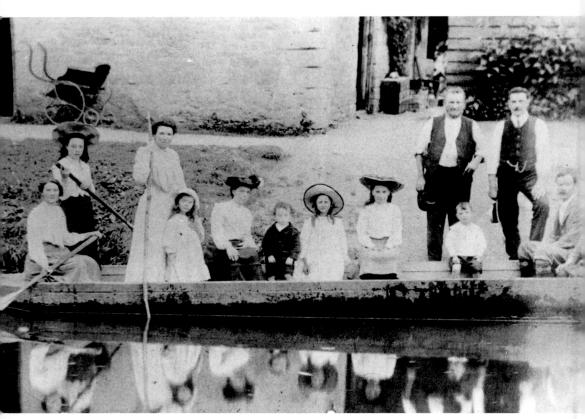

AT INGLESHAM JUNCTION, *c.* 1905. Mr John Rawlings, the gentleman with the unbuttoned waistcoat, was the last lock-keeper here and lived in the roundhouse. He is seen here with his family and two others alongside the small warehouse. The boat was probably mostly used for maintenance purposes or visits to Lechlade, but this occasion seems to be a pleasure trip.

River Thames

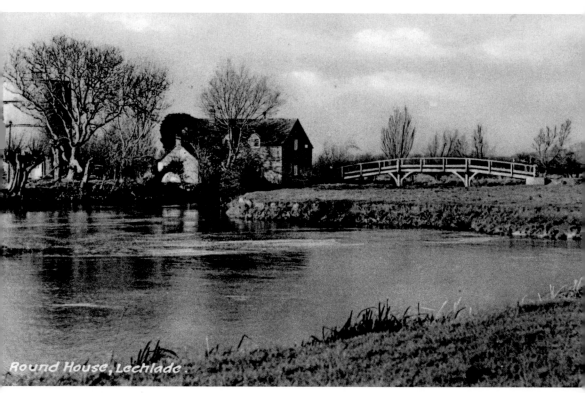

Round House, Lechlade

ABOVE INGLESHAM JUNCTION on the River Thames, *c.* 1945. This view is just upstream of the junction and shows the whole complex at Inglesham as the River Thames curves round through an S-bend downstream. On the left is the Roundhouse and down behind it would be the lock dropping the canal down to the river level on the corner. In 1929 the original small warehouse was converted into the house seen here. The wooden bridge took the towpath over the river and on to the Thames and Severn Canal Parkend Wharf at Lechlade by the Half Penny Pike Bridge.

THE RIVER COLN joins the River Thames, *c.* 1935. The two rivers join on the bend where the canal enters. The water from the Coln substantially increases the flow of water in the Thames. The footbridge carries the towpath across the Thames on the right.

Lechlade from Meadows.

THE RIVER THAMES approaching Lechlade, *c.* 1910. Barges would have come out of the canal onto the river here. Note the well-used towpath, Lechlade church spire, and the Halfpenny Bridge in the distance.

TWO VIEWS OF PARKEND WHARF at Lechlade, *c.* 1910. Coming down the river (top) are the maltsters buildings on the left by the trees. Looking back up the river (below), the canal joins the river by the group of poplar trees and then the river meanders down to the wharf. Note the agent's house and offices on the right, the warehouse in the centre, the large pile of reeds and coal on the wharf, and the entrance into the wharf from Thames Street.

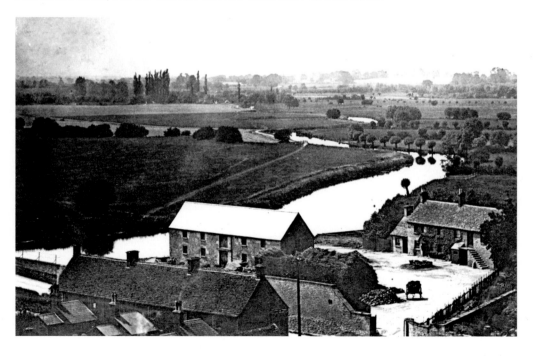

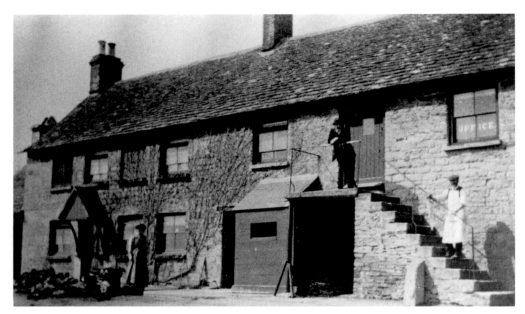

PARKEND WHARF AGENT'S HOUSE, *c.* 1915. This was an established trading wharf on the River Thames when it was built by the Canal Company in 1813 as a base for their eastern operations. This building was probably once a barge-master's house, but was altered into the canal agent's house, office and workshop.

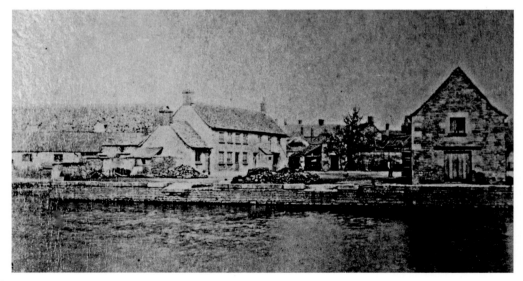

PARKEND WHARF (*c.* 1895), showing the wharf from the opposite side of the river. There is a large pile of coal on the wharf, and a pile of stone over by the agent's house. Other, more valuable or perishable goods, would have been stored inside the warehouse on the right. Interestingly, some of the large blocks of stone edging the wharf have been removed, probably to make barge-loading easier.

HALFPENNY PIKE BRIDGE, 1903.

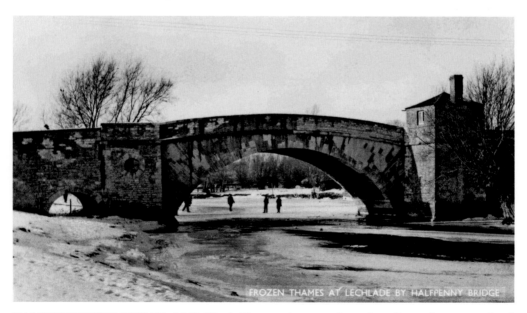

HALFPENNY PIKE BRIDGE, 1963. The bridge gets its name from the tollgate that once existed here. Canal and river traffic leaving the wharf started its long voyage down the river from here. Parkend Wharf is operated (top) by G.J. Hicks, trading as 'Coal, Corn and Salt Merchants, Maltster etc., Hay Straw always in stock'. The lower view shows the restriction to navigation caused by a hard winter, with the river frozen across. Other restrictions to navigation such as floods, low water and excessive unchecked weed growth could be equally disruptive.

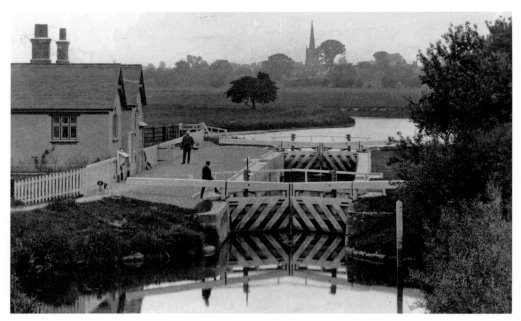

ST JOHN'S LOCK, *c.* 1900. The first lock on the River Thames, St John's was reached about one mile down river from Parkend Wharf. It was built in 1873 and made great improvements in the navigation of these upper reaches of the river. It probably replaced a flash lock.

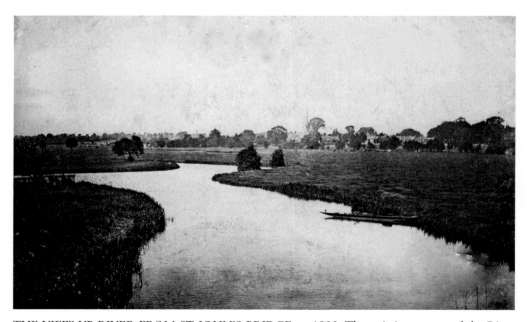

THE VIEW UP RIVER FROM ST JOHN'S BRIDGE, *c.* 1900. The twisting course of the River Thames looking back towards Lechlade is clearly visible. Note the spire of Lechlade church in the background, a noble landmark in this flat countryside.

Acknowledgements

Many of the photographs used in this volume have come from private sources and family albums. We are indebted to those who have kindly loaned them for use. Without their help this volume could not be as comprehensive as it is. Grateful thanks go to those who have allowed us to draw on their memories. Some mentors have passed on, but their memories have been recorded in our notes.

We are especially thankful for the loan of photographs from Howard Beard, David Burton, Tony Langford, and Lt. Col. Lacy-Johnson, who was particularly helpful with the section on Edwin Clark, his grandfather.

We would also like to mention the following people, whose help has supplemented our own collection of photographs and has enabled us to complete the second volume:

Mrs M. Boakes • Mrs M. Bray • B. Carter • R. Clarke • J. Garner
Gloucestershire Records Office • M. Goodenough • Mrs W. Grant
P. Griffiths • L. Harrison • B. Hillsdon • O. Hunt • A. Lasbury
Miss Leach • F. Lloyd • E. Martin • Mrs J. Martin • S. Matthews
W. Merrett • Mrs I. Muir • Miss M. Niblett • L. Padin • Miss S. Padin
R. Pearman • R. Pond • A. Pope • M. Riddihough • B. Rushby
Mrs Shepston • Mrs J. Shipman • A. M. Simpson • Mrs H. Smart
Mrs F. Smith • Mrs Steele • J. Stephens • Mrs M. Stephens • P. Sturm
I. Thomas • Mrs Thurston • D. Viner

Also available from Amberley Publishing

The Stroudwater and Thames
& Severn Canals
From Old Photographs
Volume One

Edwin Cuss & Mike Mills

ISBN 978-1-84868-786-8
£12.99 PB, 160pp

Available from all good bookshops or order direct
from our website at www.amberleybooks.com